W9-BXY-654

SIGNS OF LIFE

The Five Universal Shapes
and How to Use Them

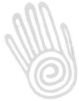

SIGNS OF LIFE

The Five Universal Shapes
and How to Use Them

ANGELES ARRIEN

ARCUS PUBLISHING COMPANY
752 Broadway / P.O. Box 228
Sonoma, CA 95476

The author and publisher gratefully acknowledge permission to use quotations from the copyrighted works listed below. In every case, diligent efforts were made to obtain permission to reprint selections from previously published work. In a few instances, publishers did not reply in time for formal acknowledgment. Any inadvertent omissions will be corrected in future printings upon notification to the publisher.

Two selections from *The Primal Mind* by Jamake Highwater. Copyright © 1981 by Jamake Highwater. Reprinted by permission from HarperCollins Publishers. Two selections reprinted from *Black Elk Speaks* by John G. Neihardt, by permission of University of Nebraska Press. Copyright 1932, 1959, 1972, by John G. Neihardt. Copyright © 1961 by the John G. Neihardt Trust. Copyright © 1990 by Piero Ferrucci. From the book *Inevitable Grace* and reprinted with special permission from Jeremy P. Tarcher, Inc., Los Angeles, California; and from Thorsons, a division of HarperCollins Publishers Limited, London. A selection from Aristotle, reprinted with permission from Great Books of the Western World. © 1952, 1990 Encyclopaedia Britannica, Inc. Three selections from *I Ching or Book of Changes*. Richard Wilhelm and Cary F. Baynes. Reprinted by permission of Princeton University Press. Two selections from Octavio Paz. *Configurations*. Copyright © 1965 by Octavio Paz and Denise Levertov Goodman, 1967 by Octavio Paz and Lysander Kemp. Reprinted by permission from New Directions Publishing Corporation. Five selections from "Simple Truths," newspaper column by Lynn Whitely Novy, *Argus Courier*, Petaluma, California. Reprinted by permission of Lynn Whitely Novy. From *Woody and Me* by Mary Neville. Copyright © 1966 by Mary Neville Woodrich and Ronni Solbert. Reprinted by permission of Pantheon Books, a division of Random House, Inc. Five selections from *A Dictionary of World Mythology*, 1986 by Arthur Cotterell. Reprinted by permission of Oxford University Press. From *The Woman's Encyclopedia of Myths and Secrets* by Barbara G. Walker. Copyright © 1983 by Barbara G. Walker. Reprinted by permission, HarperCollins Publishers. From *The Tao of Relationships: A Balancing of Man and Woman* by Ray Grigg. Copyright © 1988 Humanics Limited. Reprinted by permission from Humanics Limited. From the article "Spatial Archetypes," by Mimi Lobell from *Revision: A Journal of Consciousness and Change*. Reprinted by permission from Nityananda Institute. From *Times Alone: Selected Poems of Antonio Machado,* translated by Robert Bly. Translation Copyright © 1983 Robert Bly. Wesleyan University Press. Reprinted by permission of the translator and University Press of New England.

Copyright © 1992 by Angeles Arrien.
All rights reserved. Published 1992

Cover Design, Book Design, and
Original Art Work
Copyright © 1992 by Peggy Mackenzie.
All rights reserved

Printing coordinated by Interprint
Printed in Thailand

Library of Congress Cataloging-in-Publication Data
Arrien, Angeles, 1940 -
Signs of life: the five universal shapes and how to use them
by Angeles Arrien; book design by Peggy Mackenzie.
p. cm.
Includes bibliographical references; includes index.
ISBN 0-916955-10-9: $14.95
1. Preferential Shapes Test. 2. Symbolism (Psychology)
3. Symbolism (Psychology)--Cross-cultural studies. I. Title.
BF698.8.P74A77 1992
153.3'2--dc20 91-24250
 CIP

CONTENTS

Tatooed man from Marquesas Islands.

OTHER BOOKS BY ANGELES ARRIEN:

THE TAROT HANDBOOK:
*Practical Applications of
Ancient Visual Symbols*

THE FOUR-FOLD WAY:
*the Paths of the Warrior,
Teacher, Healer and Visionary*

For my mother

MARIA CRUZ ELORDI ARRIEN

. . . an eternal ally and source of inspiration whose loving heart, dignity, courage, and generosity of spirit lives in all that she created. I especially remember her lively, active hands bringing the power of beauty into all that she touched: her many quilts and yarn paintings, the clothing she made for her two daughters, and her magical kitchen and garden.

8, 9 Lotus and Lakshmi's footprints, Banasthali, India.

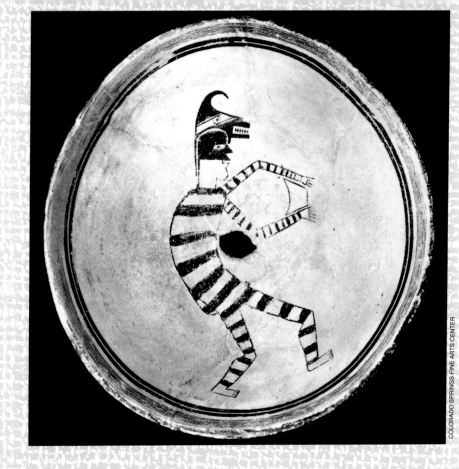

COLORADO SPRINGS FINE ARTS CENTER

Among the language of American
Indians there is no word for "art."
For Indians everything is art . . .
therefore it needs no name.

— Jamake Highwater

PART I
The Significance of the Five Shapes

IHAVE ALWAYS BEEN INTRIGUED by the variety of ways that people of diverse cultures handle similar life experiences. Since childhood I have been fascinated with folklore, myths, and fairy tales from different cultures. It was my insatiable curiosity coupled with my desire to find a bridge between diversity and commonality that eventually led me into the field of cultural anthropology. This interdisciplinary arm of anthropology allowed me to study the history, art, philosophy, music, psychology, and religions of the peoples of the world. It is from this integrative approach that I have continued to look at the areas that every culture addresses in its own way: education, health care, family systems, governance, economics, communication, artistic expression, religion, and beliefs in the supernatural.

As a natural progression of my work in the field of cultural anthropology, I began to specialize in multi-cultural themes. For the last twenty-five years, my creativity has been magnetized toward exploring the meaning and significance of myths, symbols, and human values from a cross-cultural perspective. During this period, I have studied many cultural sources and collected examples of visual and literary expression that illustrate similar themes. I have spent countless hours in museums, libraries, cultural exhibits and archives, and I have supplemented the material I found in this research with direct experience through travel.

10 **a–*Background***: Woven cloth; **b–*Lower left***: Ancient Japanese coin design; **c–*Photo***: Mimbres pottery bowl, New Mexico, A.D. 1100–1250.
11 **a–*Upper left***: Mosaic flooring, Temple of Zeus at Olympia, Greece; **b–*Middle right***: Ancient Japanese coin design.

I have researched the origins of over twelve hundred different symbols to learn about the consistency of meaning given to each symbol by the different societies in which it is found. *The Tarot Handbook: Practical Applications of Ancient Visual Symbols* was the first result of this inquiry.

In 1980, I became interested in finding out if there are certain shapes found in the art of most cultures and ages. I wanted to know what meanings, if any, human beings attribute to these shapes and whether the meanings are similar in various cultures. I wondered whether there are collective human experiences that are consistently recognized and deepened when these shapes are expressed artistically by people of different times and cultures. I began a cross-cultural study to discover possible answers to these questions.

Over the next seven years of research and application of the emerging material, I discovered that five basic shapes appear in the art of all cultures: the circle, the square, the triangle, the cross, and the spiral.

The study also confirmed that people in different cultures do give similar meanings to these shapes. The circle symbolizes *wholeness*, the square indicates *stability*, the triangle represents *goals and dreams*, the cross stands for *relationship*, and the spiral means *growth*. It also became evident to me that the meaning attributed to each shape stands for a process of human growth, and the shape carries this process within itself.

12 Renaissance chair (Bajot). **13 a–*Lower left*:** Native American painted rawhide box; **b–*Upper right*:** Man as microcosmos, ancient Greek drawing.

Using these five universal shapes, I developed the **Preferential Shapes Test** as an effective tool that can be used to determine the connection between a person's preferences for certain shapes and the same person's inner, subjective states.

In my research with myths and fairy tales, I noticed that characters in these stories often had to make a life or death choice involving objects, people, riddles, questions, animals, and other items. I discovered that no matter how many or how few objects are available to choose among, the obvious choices are rarely correct. I also learned that there is one particular choice that is the fairy-tale-character's key to transformation and liberation.

One example illustrating the choice process is in the fairy tale, *"Goldilocks and the Three Bears."* Goldilocks sits in each chair, tastes each bowl of porridge and tries each of the beds until she finds one that is "just right."

Do you remember a favorite fairy tale in which a character has to choose between many things to find something that is just right?

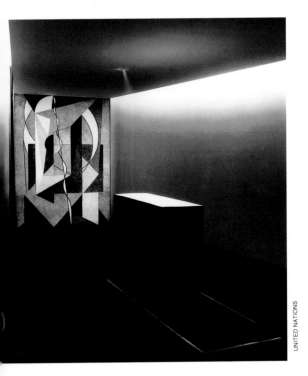

UNITED NATIONS

I used the information I had found in this research to determine the meanings of the positions in the **Preferential Shapes Test.** These positional meanings correspond with what is archetypally found in fairy tales when characters are faced with life-changing choices.

It was my belief that when people take the **Preferential Shapes Test**, they will repeat the similar archetypal process of choice-making used by characters in myths and fairy tales, that they will make a certain predictable preferential choice which will be the key to their current growth process.

To assess my theory and to discover whether the **Preferential Shapes Test** is a viable tool for self-discovery, I gave this test to over two hundred of my graduate students at the California Institute of Integral Studies, J.F.K. University, and the Institute of Transpersonal Psychology. The significance of their test results enabled me to present this material to over six thousand workshop and conference participants of many different ages and cultural backgrounds from 1981 to the present. The results confirmed my hypothesis. Over ninety percent of all students and of all workshop and conference participants validated that there is one positional choice that is a relevant tool for assisting transformation in current life situations. Results from

14 a–*Photo*: Meditation Room, United Nations, New York; **b–*Bottom border*:** Wasp nest symbol, Brazil.
15 Birchbark basket, Shuswap, British Columbia.

the test also revealed that shape preferences are a good barometer of inner processes. The five shapes, I concluded, are indeed external symbols of internal psychic states.

The preference for particular shapes is an announcement of the values and processes active at any time for an individual, a group, or a whole society. As one becomes sensitive to the shapes, one will see them in many forms, such as in doodles, business cards, corporate logos, and art collections. Modern architect Mies van der Rohe tells us, "Architecture is the will of the age conceived in spatial terms."

The meaning ascribed to each of the five shapes symbolizes and demonstrates an individual's or a culture's *world view*: the qualities, characteristics, belief structures, actions, and forms of expression used by one person or shared by the members of a society. **The Preferential Shapes Test** allows a person to discover one's own current *world view*. The information in this book can also lead to a greater understanding of the *world view* of other individuals, of one's own culture, and of other cultures.

Individuals can use this book on their own to discover and focus on their personal processes. Parents, teachers, employers, managers, therapists and others can work with their children, students, colleagues, employees, and clients to better understand how human beings live through and experience the universal processes of change embodied in these five symbols.

The sequence in which someone places the shapes when taking the test is most important in showing which of the five universal processes of change and growth is being experienced most intensely by that person at that time.

In addition to my explanatory text, this book includes visual images, statements from recognized artists, and poetry from each continent. Examples from nature, art, literature, architecture, advertising, religion, and myths are used to show the pervasiveness of these five shapes, and of the processes they represent, in the lives of people from all cultures.

The value and meaning of the shapes and their undeniable presence in our lives was recognized by all our ancestors. The Native American elder in *Black Elk Speaks* eloquently expresses this recognition.

While I stood there I saw more than I could tell, and I understand more than I saw; for I was seeing in a sacred manner the shapes of all things in the spirit, and the shape of all shapes as they must live together like one being.

Who can afford to live without beauty?
Beauty fills us with passion;
it graces us with joy and lights up our existence.
A landscape, a piece of music, a film, a dance —
suddenly all dreariness is gone, we are left bewitched, we are dazzled.
If we get lost in dark despair,
beauty takes us back to Center.

— Piero Ferrucci

According to Carl Jung, the powerful forces of the unconscious appear, not just in clinical material, but also in mythological, religious, artistic, and in all other activities humankind uses to experience itself. Jung advocated the symbol as the psychological mechanism that transforms energy.

Joseph Campbell tells us, ". . . it is the artist who brings the images of a mythology to manifestation, and without images (whether mental or visual) there is no mythology." It is the artist within us who communicates our own mythology through our thoughts and feelings as expressed in paintings, sculpture, writing, music, and dance. Using these and other media, we reveal ourselves, our concept of beauty, and what is culturally important to us. Some statisticians believe that most of our communication is non-verbal and is manifested through symbols and myths. The

16 **a–*Lower left*:** Lever House, New York;
b–*Center*: Architectural perspective drawing.
17 ***Lower right*:** Graphic symbol.

human ability to use stories and visual images to communicate clearly is continuing to evolve according to time, place, culture, and person.

Isamu Noguchi, the designer of the Unesco Gardens in Paris, described the process of transformation found in art, in mythology, and in communication as an *awakening*.

*I don't think that art comes from art. A lot of artists apparently think so. I think it comes from the awakening person. Awakening is what you might call the spiritual. It is a linkage to something flowing very rapidly through the air, and I can put my finger on it and plug in, so to speak. Do artists need a spiritual way or do they need art? You can say that one is the same as the other. Everything tends toward awakening, and I would rather use the word **awakening** than a word derived from some system — because there are many systems.*

— Isamu Noguchi

Communication and media have gone through their own *awakening*. Originally, it was Aristotle who stated ". . . the soul never thinks without an image." Philip R. Harris and Robert T. Moran put Aristotle's thought into a modern context when they wrote, ". . . in a very brief span in history, humankind's communication tools have evolved from smoke signals and drums to television and satellite . . . Human interaction is characterized by a continuous updating of the meaning of . . . symbols. In the past twenty-five years, we have expanded our capacities for symbolic communication beyond what was accomplished in the previous twenty-five hundred years."

As it *awakens* and evolves, human nature demands new and improved ways of communicating, using both old and new media such as the radio and the computer.

The *I Ching*, the oldest known book which addresses the process of change, reinforces the way existing forms and images in human society reshape themselves for purposes of supporting change and evolution:

In human affairs, aesthetic form comes into being when traditions exist that, strong and abiding like mountains, are made pleasing by a lucid beauty. By contemplating the forms existing in the heavens, we come to understand time and its changing demands. Through contemplation of the forms existing in human society, it becomes possible to shape the world.

—I Ching, Hexagram #22, *Grace*

ISAMU NOGUCHI FOUNDATION, INC.

18 *Photo*: UNESCO Gardens, Paris, designed by Isamu Noguchi. **19** Shri–yantra, cosmic design, India.

In conclusion, I want to say again how important I believe it is to remember that the order of preference chosen for the five shapes is an announcement of the values and processes active at any given time for an individual, a group, or a society.

It is my hope that this material and the following **Preferential Shapes Test** will provide people with a tool that can be used to *awaken* a greater understanding of themselves and of their environment. This book represents a beginning exploration of a cross-cultural overview on this subject. I encourage others to use this material as a tool to expand the concept and possibilities of this work.

Let me know what you discover.

I am a history
A memory inventing itself
I am never alone
I speak with you always
You speak with me always
I move in the dark
I plant signs

— Octavio Paz

20, 21 Mimbres bowl, New Mexico/Arizona
ninth–twelfth centuries.

I will speak to you in stone-language
(Answer with a green syllable)
I will speak to you in snow-language
(Answer with a fan of bees)
I will speak to you in water-language
(Answer with a canoe of lightning)
I will speak to you in blood-language
(Answer with a tower of birds)

— Octavio Paz

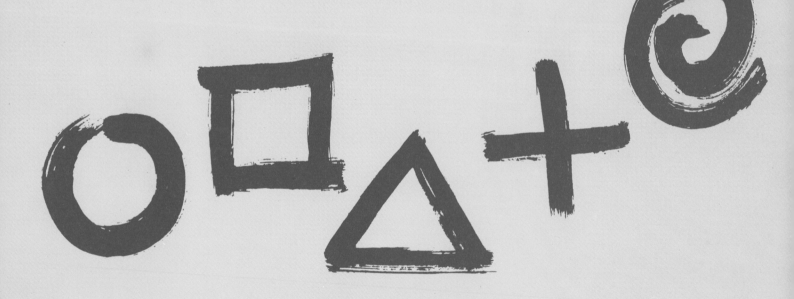

PART II
THE PREFERENTIAL SHAPES TEST

THE PREFERENTIAL SHAPES TEST provides a window on individual experiences and needs, as well as clues to the direction of future growth. It is *not* intended as an index of character flaws. The processes revealed by the shape preferences are a part of everyone's experience. The potentials symbolized by each shape are present in everyone, although their expression in any individual is always unique.

In order to find out your present and future processes of change and growth, please take the following Preferential Shapes Test before you read the rest of the book.

Instructions for taking the Preferential Shapes Test:

The five universal shapes are: circle, square, triangle, cross, spiral.

Step 1: *Draw the shapes listed above on a sheet of paper.*

Step 2: *Number the shapes 1 through 5 in the order of your preference. Number 1 will be your most preferred shape and Number 5 will be your least preferred shape. Please make your preferential choices before you read further.*

Step 3: *To interpret your test results, read the following pages to understand the meaning of each position and the meaning of each shape.*

The Preferential Shapes Test © by Angeles Arrien 1992

22 Contemporary American brush calligraphy.
23 a–*Upper left*: *See d, Pages 24–29.* **b–*Right border*:** Torn paper.

Interpreting the Test Results—Part One

The Meanings of the Positions

The first step of the test interpretation is to analyze the order of preference you selected for the shapes, Positions 1 through 5. As you numbered the shapes according to your preference, you created a current map of your own inner landscape, giving an overview of your aspirations, resources, needs, and fears. The descriptions that follow explain the meaning of each position in relation to the shape you placed within it.

Position 1 — *Where You Think You Are:*

The shape placed here, in this most preferred position, signals the process that now has your attention; it describes the part of yourself of which you are most aware and with which you are most comfortable at this time. The shape in Position 1 indicates your idea of the future or, perhaps, your current source of inspiration. But — and this is critical to proper interpretation of the test results — it is not the most accurate indicator of where you actually are right now. It only shows you where you think you are or where you would like to be. You may find that you

often notice this shape in your environment, that you are strongly attracted to it, and that you admire the qualities of the process it represents.

Position 2 — *Your Strengths:*

The shape you have chosen as your second preference exhibits an inherent strength predominant in you at this time, whether you know it or not. You demonstrate this strength to other people without effort. The shape in this position indicates areas of your nature that are currently fluid, strong, and resourceful. This shape reveals the innate talents you are using to assist the growth occurring in Position 3. Many people, who have taken this test, report that recent positive feedback and compliments they have received from others correspond to the qualities of the shape found in Position 2. Consider the recent comments that have come your way from friends, family, and colleagues. Do they align with the qualities attributed to the shape you have selected for this position?

24 *(Repeated over next six pages) Left to right:* **a**–Graphic shield design, square pattern; **b**–Clay spindle whorl, monkey, pre–Columbian; **c**–Fish scale pattern, family crest design, Japan; **d**–Clay stamp, Tlaxcala, Mexico; **e**–Egyptian geometric seal design.

Position 3 — *Where You Are:*

Though this shape is third in your order of preference, it is the most significant: the shape you put in this position shows your true current growth process. This shape stands for the work that is really going on, right now, at the core of your being. Very often this process is unconscious or overlooked, yet you must be aware of it in order to fully manifest the potential it represents. In choosing among multiple alternatives, fairy tale characters selecting the middle choice most often achieve their desired result. Their first two choices rarely give them what they want. As with the choice-makers in fairy tales, your third or middle selection is significant. It is most often considered the right answer. It indicates where your own gifts can be used correctly now. The shape in this position can be a source of unlimited creativity and healing when you support the process it signifies. Now that you have discovered this shape in this meaningful position, you will be able to consciously acknowledge its visual presence and significance in your life. You may be surprised to find this shape all around you, where you have not noticed it before.

Position 4 — *Your Motivation:*

Position 4 points to past challenges, tests, and circumstances that have motivated your current process of change. The fourth position of preference and the shape within it discloses the motivation that triggered your move into the core work to be done that is symbolized by the shape in Position 3. This shape furnishes clarifying information about the underlying incentive that has provoked you to do things differently now. Many people have reported that the shape found in this position also describes situations they have resolved or moved beyond. You may notice this shape only occasionally; it can serve as a reminder of where you have been and to direct your attention to the shape and process in Position 3.

Position 5 — *Old, Unfinished Business:*

This shape, your least preferred, identifies a process you have outgrown or one that you dislike, still resist, or are judging. It indicates old, perhaps unfinished business. This fifth position is associated with unresolved issues you now wish to put aside. The shape placed here carries a process that you will reclaim and integrate at a later date. It is not work to which you should attend in the present; instead, it shows areas of boredom, patterns of denial, or disowned parts within yourself. When you see this shape in the world around you, you may feel disinterested, or even irritated. You seldom want to be reminded of the process it represents.

Interpreting the Test Results — Part Two

The Meanings of the Five Shapes

The second step of the test interpretation hinges on the meaning of the processes of change and growth associated with each shape. The meanings attributed to the shapes describe universal aspirations, needs, and fears; each shape symbolizes a specific inner and outer experience relevant to humankind.

The following sections explain the universal meaning attributed to each shape.

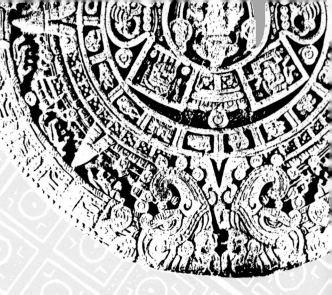

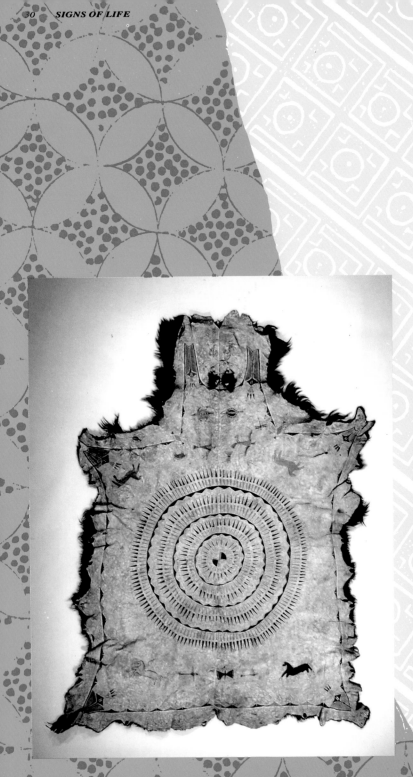

CIRCLES

. . . Everything an Indian does is in a circle,
and that is because the Power of the World
always works in circles,
and everything tries to be round.
. . . The sky is round,
and . . . the earth is round like a ball,
and so are all the stars.
The wind, in its greatest power, whirls.
Birds make their nests in circles,
for theirs is the same religion as ours.
The sun comes forth and goes down again in a circle.
The moon does the same, and both are round.
Even the seasons form a great circle
in their changing,
and always come back again to where they were.
The life of a man is a circle from childhood to childhood,
and so it is in everything where power moves.

THE CIRCLE

Wholeness

IN EVERY CULTURE the circle symbolizes wholeness and the experience of unity. When people are engaged in the search for wholeness they aspire to independence and individuation. What they need most is space, room in which to find themselves and develop their own identity. What they fear most is entrapment, being caught in a situation that will restrict or restrain them.

Those who are undergoing the process of individuation will feel loved and trusted when allowed plenty of space. If the space they need is not offered to them, they will simply take it. When the process of individuation is resisted or not allowed to come to resolution, it may become intensely self-absorbing, even narcissistic.

Sharing each other's results from the **Preferential Shapes Test** is an effective way for people to work together. By doing so, others can discover and explore ways in which to be supportive of the person experiencing the individuation process. Clarity about spatial needs is essential for mutual support. It is wise to wait and to allow the person who is in the process to initiate contact and communication.

30 a–*Left background*: pattern from Ashanti beaten bronze urn, Ghana; **b–*Right background*:** Bambara dyed cloth pattern, Mali; **c–*Left foreground photo*:** Buffalo robe, Plains Indians, North America; **d–*Upper right*:** Carved stone Aztec calendar, 1500, A.D., Mexico.
31 a–*Lower right*: Mimbres bowl, New Mexico, ninth–twelfth centuries; **b–*Right border*:** Torn paper.

KUNAPIPI

*Kunapipi is the mother goddess of the aboriginal tribes of northern
Australia. Now a vague, otiose, spiritual being, "the old woman"
once traveled across the land with a band of heroes and heroines,
and during the ancestral period she gave birth to men and women as
well as creating the natural species. A "rainbow serpent" went
before in order to prepare her way.*

—Ancient myth from Australia

The thrust toward individuation is represented in Eastern cultures by
the circular form of the mandala. One representation in Western cultures
is the circular business logo that asserts uniqueness of corporate identity.
The circle is found in the art of every culture and time. From Native
American medicine wheels to Hawaiian Menehune rings, the circle
remains humankind's primary symbol for unity and stands for the mythic
theme of individuation.

Mythologist Joseph Campbell reminds us in his book, *The Hero
With a Thousand Faces*, that the myths most associated with the process
of individuation are the stories every culture tells about its heroes and
heroines. At first these tales were passed from one generation to the next
orally — in poem, story, and song. Later, written literature grew from the
oral tradition. The journey of the hero or heroine is a universal myth
found in the lore of all cultures, including Greece, Rome, Asia, Africa,

32 a–*Upper left*: Bronze arm band, Anglo–Saxon,
Great Britain; **b–*Left center*:** Painted terra cotta
dish, Dolmetsch; **c–*Lower right*:** Center ornament
from gold necklace, Etruria; **d–*Center*:** Pottery
bowl, lustre glaze, Iran, twelfth century.
33 a–*Lower center*: Half–moon bronze armor
ornament, Anglo–Saxon, Great Britain; **b–*Left*:**
Wooden mask, Baule, Ivory Coast, Africa.

Nordic and Oceanic societies, the Americas, and contemporary indigenous folk groups.

These tales, both ancient and modern, continue to encourage and inspire us. Stories for children and daily life experiences hold heroic themes. We are often reminded of the courageous accomplishments of heroes and heroines such as Prometheus, Psyche, David, Samson, Sigurd, Cu Chulainn, Lancelot, Galahad, Paul Bunyan, Cassandra, Odin, Joan of Arc, Pele, Coyote, Buffalo Woman, Obaluwaye, Quan Yin, Maira, *Alice in Wonderland*, Dorothy from *The Wizard of Oz,* and countless others.

All heroic myths describe the process of individuation and the reclamation of self. The stories recount simple beginnings, initiations, identified strengths and resourcefulness, victorious struggles with powerful forces, the resolving of issues regarding *hubris* or pride, and the exploration of persistent unanswered questions. Near the end of the journey a betrayal is often rectified or a courageous sacrifice is accomplished in triumph or in despair, through death or a new beginning.

Often, we have important long-standing questions that provoke our own heroic journeys. In the modern-day story of individuation at the end of this section, *Feeling Good About Grandma*, Emily has a question about whether someone can see if she has a black heart. She begins her own journey by unraveling this question, which allows her to discover her heart's true color.

The ancient Australian myth about Kunapipi on page 32 sheds additional light on this process in conveying to us that each journey is connected to a spiritual source, to a creative dream that inspires us to become our heroic selves and join with other heroes and heroines to expand ancestral roots and create new worlds.

PERSONAL TEST INTERPRETATION

Which ancient and modern heroes and heroines would you add to the list of examples given earlier? Those that come to mind have been and will continue to be important sources of inspiration for you in your own individuation processs.

What significance do circular shapes have for you? Do you notice them everywhere you look, or not at all? Do you draw them in your doodles? Are you strongly attracted to or repelled by them? Your answers will help to show you where the process of individuation is presently located on your inner map and whether it now requires more of your attention.

Your relationship to your own heroic journey is made clear by where you have placed the circle when you took the Preferential Shapes Test. *If the circle is in Position 1 it indicates your desire to be independent and self-sufficient. This is the process that has your attention and*

34 **a–*Left center*:** Lustre pottery bowl, scene from epic story, Syrian prince on throne, twelfth century; **b–*Lower left*:** Chinese circle design; **c–*Upper right*:** Seven circle design, Khurasan, Iran, tenth century. **35 a–*Lower left*:** Chinese plate; **b–*Middle right*:** Pre–Columbian clay spindle whorl, flower design.

that is a source of inspiration to you. The circle in Position 2 means that the heroic journey currently is effortless for you, whether or not you are aware of that. Your heroic behavior points out to others that your strengths are self-reliance and resourcefulness. In Position 3, the circle shows that the process of individuation is occurring at the core of your nature. When fully engaged, this process of achieving and experiencing independence will allow your natural creative and restorative abilities to flow into all areas of your life. The circle in Position 4 denotes that a past heroic journey motivated you to become responsible and self-reliant. The process of individuation was the past challenge that caused you to move to your present core work (defined by the shape you have placed in Position 3). When the circle is in Position 5, you may be resisting or denying the process of individuation. The heroic journey currently does not have your attention and you have no interest in exploring it at this time.

By learning about the process the circle represents, and about the meaning of the position in which you placed it when taking the **Preferential Shapes Test***, you will add more information and detail to your inner map. You will also become more aware of and responsible for your present relationship to the process of individuation.*

Simple Truths/*Lynne Whiteley Novy*

FEELING GOOD
ABOUT GRANDMA

W E'VE BEEN trained to feel good and, it turns out, that's bad.

A shy young woman I'll call Emily told me, matter-of-factly, that she was afraid she had a black heart. The way she looked me in the eye held the question: "Can you tell from out there?"

Concerned because she didn't care that her grandmother was dying, she said, "Everyone thinks Grandma is wonderful except me. I have to pretend that she is."

Quietly, without emotion, Emily painted a colorless word picture of a childhood in which, when she was with Grandma, she was Gretel alone in the woods with the witch.

She remembered a time when at age five she had blasted her grandmother, calling her a mean, hateful old lady. "My mother grabbed me and shook me until my eyes hurt," Emily said. "Then she told me: 'Don't feel anything but good about Grandma'."

So, for the last 25 years, Emily hasn't felt much of anything, except bad about herself. Her interior process goes something like this: Good about Grandma is the only okay way to feel. I can't feel good about Grandma. I'd better not feel anything because if I do it'll be bad and then so will I.

A black heart.

Emily's dilemma feels familiar. I remember growing up with plenty of admonitions against so-called bad feelings. We've all heard renditions of these:

Don't be upset or sad or give into any messy feelings that require tears. (My father's personal favorite "stop that blubbering" left me sputtering like a beached whale.)

Don't be aggressive or frustrated or display any loud feelings that might explode. (When I roared after a kid who bounced a basketball off my head, the school principal's "You'd better watch that temper, young lady" made it clear that he preferred plague to anger.)

— The Search for Wholeness

Don't be anxious or hesitant or exhibit any fearful feelings that need consolation. (Standard dictums in our family included "Don't be a scaredy cat" or my mother's special "Don't be a worrywart" or just plain "Don't be silly.")

The operative phrase, of course, is Don't Be.

When we get cut off from our bad feelings, we also lose access to our good ones. Then we Can't Be. With feelings dulled, we miss out on the richness of life experience.

It's through our feelings that we access our personal truth. We can't value or trust ourselves if we invalidate that experience.

Feelings are my guidance system. Without the whole range of them, I have no clues as to what's right for me. If I don't know what I want, I can't make choices. This means I have to depend on the outer world to tell me how to be and what to do.

We all know that life has ups and downs, good days and bad. We say we respect the whole spectrum of feelings. But we still live, I think, under the deep spell of a cultural myth that goes

something like this: Pain leads to unhappiness. Bad feelings are painful. So, to be happy, allow only good feelings.

Sounds like it sorta makes sense. Except it's not true. It's the magical thinking of children.

Perhaps we think like this because, emotionally, most of us are still children. Well, I won't presume to speak for you, but this sure applies to Emily and me.

How could it be otherwise? We've been formally educated and encouraged to grow mentally and physically. But emotionally we've been managed and controlled.

We stunt, rather than foster, emotional growth. We fear feelings and cut them off rather than exercise them, learn from them, and let them mature.

Don't feel anything but good about grandma.

I remember this when I'm stuck with my own black heart. I think of Emily, and when I recall the true color of her heart, my own is reflected back to me.

—© 1991 Lynne Whiteley Novy

36, 37 Entwined circular pattern.

Man, alone in his manliness, is incomplete.

Woman, alone in her womanliness, is incomplete.

Such eager struggle as each searches to find the other so there is both.

So it is that there is man and woman and the fulfillment of each is other.

— Ray Grigg

DAVID MOORE. TIME–LIFE BOOKS, INC.

THE EQUIDISTANT CROSS
Relationship

THE EQUIDISTANT CROSS, the plus sign, universally symbolizes the process of relationship and integration. This is a coupling, synthesizing, integrating and balancing process. This process carries the need for connection — to a creative project, to a group, to another person, or to oneself. It is the symbol that demonstrates integration and balanced connection.

People who favor the cross will place emphasis on the quality, not the quantity, of time shared with others. Experiencing balance will be an essential goal for them. These individuals will often ask for a specific meeting time; they love collaborative work; and they equate quality of time spent in the company of colleagues and close friends with love and trust.

For others who want to support people who are in the cross process, it is important to be responsive to their stated needs, to honor their requests for shared time and activities, to be cooperative, and to express caring.

The underlying fear associated with the process of relationship is the fear of loss, abandonment, and isolation. When the process of relationship, or needing connection, is taken to an extreme, personal identity can be lost if the individual tries to live life through another person or through a group.

38 **a–*Background*:** Celtic key patterns, Great Britain; **b–*Lower left photo*:** Carved wooden statue of famed Maori lovers Tutanekai and Hinemoa, New Zealand; **c–*Upper middle*:** North American Indian pottery vase, Arkansas; **d–*Middle right*:** Brass clasp, Galicia.
 39 **a, b–*Upper right and middle*:** Weaving design elements, Bushongo, West Africa; **c–*Lower right*:** Magic circle, Germany, 1800; **d–*Right border*:** Torn paper.

Masewi

The twin brothers of Pueblo mythology are Masewi and Oyoyewa,
whom the universal mother sent into the world to place the sun
correctly in the sky and assign people to their clans.

In some societies the cross is viewed as a religious symbol. In many
others, it is not. Most societies see the symbol of the cross as two parts
merging to create a greater whole. In *Timaeus*, Plato tells of an unknown
creature joining up the broken parts of the world's soul by means of two
sutures in the shape of an "X", known in contemporary times as St.
Andrew's cross. In Egyptian hieroglyphics, the cross stands for life and
living (*nem ankh*) and forms part of such words as *health* and *happiness*.
These two examples explain the major cross-cultural functions attributed
to the cross — the process of relationship, integration and balance.

Most cultures refer to the relationship process symbolized by the
cross as the twin motif or the shared journey of couples. Multi-cultural
mythology contains stories of the following twins and their shared experi-
ences: Mitra and Varuna, Liber and Liberia, Romulus and Remus, Castor
and Pollux, To-Kabihana and To-Karvuvu, Sun and Dripping Water, and
Ahura and Ahriman. The twin motif in mythology offers information
about the resolution of dualities, polarities and opposing forces, when
experienced between people or within an individual.

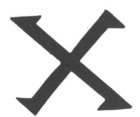

40 a–*Lower left*: St. Andrew's Cross; **b–*Upper***
center: Mother Earth, Father Sky, from Navajo
rug design.
41 a–*Upper right*: Nem ankh, Egyptian symbol;
b–*Lower right*: Cross interlacement.

The story of the shared journey expresses the value and challenge of partnership. There are a number of couples whose stories illustrate the powerful results of being in relationship. Some examples from mythology are Isis and Osiris, Zeus and Hera, Shiva and Shakti, Tristan and Isolde, King Arthur and Guinevere. The perils and promises of the shared journey are also exemplified by historical couples such as Anthony and Cleopatra, Dante and Beatrice, Heloise and Abelard, Napoleon and Josephine.

When the lives of contemporary couples capture wide attention, it indicates our recognition of the relationship process and its living presence and influence in our own time. Some examples from this category are Prince Charles and Lady Diana, Prince Rainier and Princess Grace, Franklin and Eleanor Roosevelt, Marie and Pierre Curie, Georgia O'Keeffe and Alfred Steiglitz, Frieda Kahlo and Diego Rivera, and even Raggedy Ann and Andy.

Whether found in ancient or modern examples, the theme of the shared journey is one of cooperation, teamwork, and partnership. When two or more join together, something greater and more powerful is created. This principle is described in the ancient Pueblo myth, *Masewi,* and in the modern story of relationship, *A Little Birdie Told Me*, both included in this section. Each story tells how creativity is released when two or more persons resolve a problem together.

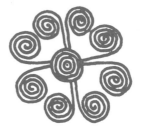

PERSONAL TEST INTERPRETATION

Are there couples from myth or literature, from the historical past, or from the present day whose stories are important to you? The couples who come to your mind in each of these categories are sources of inspiration for you and demonstrate what is important to you in your own process of relationship.

Are you often or seldom aware of the shape of the cross in your life? When you notice a cross, what is your response? Your answers will provide information about how, when, and where the process of relationship is being supported and reinforced for you.

The status of your relationship process, of your own shared journey, is depicted in the **Preferential Shapes Test** *by the position you chose for the cross. If the cross is in Position 1, it means that the process of relationship is what you believe to be most important in your life. The cross in Position 2 means that the shared journey is currently an effortless process for you, though you may not know this. Your behavior makes it obvious to others that your strength is in people skills, that you develop relationships easily, and that achieving balance is natural to you. In position 3, the cross shows that the relationship process is occurring deep within your nature. When you participate fully in this process, your originality and regenerative powers will be fully available to you. The*

42 **a–*Lower left*:** Patriarch's mitre, Russia, seventeenth century; **b–*Top right*:** Ashanti cast bronze gold weight, Ghana; **c–*Middle right*:** Russian Orthodox priest's pendant cross.
43 **a–*Background*:** Perspective drawing; **b–*Upper left*:** Cross from Notre Dame du Port, Clermont–Ferrand, France, eleventh century; **c–*Lower center*:** Painted cloth design, Ghana.

cross in Position 4 makes clear that a past shared journey inspired you to become more attentive to partnership and teamwork endeavors. The past challenge that stimulated you to begin your core work in the present as designated by the shape in Position 3. When the cross is found in Position 5, you may want to ignore or dismiss the importance of the process of relationship in your life.

As you interpret the meaning of your numerical preference for the cross, you will become more familiar and comfortable with your inner landscape. You will be able to see and understand the significance that the process of relationship holds for you at present.

Simple Truths/*Lynne Whiteley Novy*

A LITTLE BIRDIE
TOLD ME

NATURE is a great teacher, but She always catches me off-guard. Her latest lesson unfolded recently when my husband stopped me on my way through the sunroom.

"Don't spray that tree with the hose," he said, pointing out the French doors toward a dwarf pine in the courtyard garden.

I've lived with Fred, master of indirect communication, long enough to know that he could be bouncing commands to himself off of me.

Besides, innocence was mine. I rarely touch a hose unless the house is on fire. And, as the whole neighborhood knows, it's Fred who suffers withdrawal pangs since the drought curtailed his weekend escapades as Hoseman.

So I didn't take the bait.

"Why not?"

"They're building a nest." He pulled me closer to the window, and I saw a flicker of brown feathers.

"The male is the bigger one with the red breast," he said. "The little drab one is the female."

He looked at me pointedly, and I knew that last night's shutters vs. no shutters argument was still on. It was a simple dispute made complex by the nature of opposites. His basic philosophy claims "more is better." Mine runs to "when in doubt, leave it out."

Continuing with his bird lore as a way of indirectly assessing my shutters IQ, Fred asked, "Why is it that in nature it's the male bird that's always the beautiful one?"

In that moment, he looked to me every bit like a showy peacock with tail fully fanned. What I heard through the translation in my head was: "What do you mean you think we should just rip the two existing shutters off the house rather than add new ones to the bare windows?"

So, I took the bait.

"Because the male is all ego and pride," I shot back. "It's the female who knows humility."

"Oh? So what's humility?"

"Have you ever experienced what it's like

— *The Process of Relationship*

to know you're about to lay an egg, and there's not a thing you can do about it?" I heard myself and stifled a laugh.

His eyes widened in surprise. "That sounds like humility all right."

Words are not his strong suit. He took a minute to collect his defense. "Then why do women paint themselves and wear those wild earrings?" he wanted to know.

"So men can see them!" I didn't even stop to think.

The words flew out of my mouth like crazed hummingbirds. "The male is so arrogant and stuck on himself that the female has to do something to get noticed. Meanwhile," I was really on a roll, "she's also out there laying all those eggs and keeping the world going around."

Silence.

"I never thought of it that way," he said humbly.

"Me either." I felt a little singed by my own hot air. In a war of words, it always looks as if I win.

We watched the birds. The red-breasted one brought a twig to the waiting beak of the little brown one and flew off again for another. There was a grace to their quiet cooperation.

No arrogance in her humility; no pride in his beauty.

A peacefulness settled between us, and I knew the truth about the shutters. Hard as it is to admit, I have little interest and even less talent for house decor. Particularly the outsides of houses. I guess I think women are supposed to be naturally good at that. But it's Fred who is the home beautifier.

The red-breasted bird sailed into the tree with another offering for the nest. We leaned against each other, my shoulder nudging his in apology as we watched. Sometimes it's the little things that are the toughest to tell the truth about.

"You're right about the shutters," I offered.

"Thank you," he said. "But you've got a great way with words."

— ©1991 Lynne Whiteley Novy

44, 45 Amish quilt pattern *Stars and Blocks*.

The spider taketh hold with her hands and is in king's palaces.

— *Proverbs 30:28*

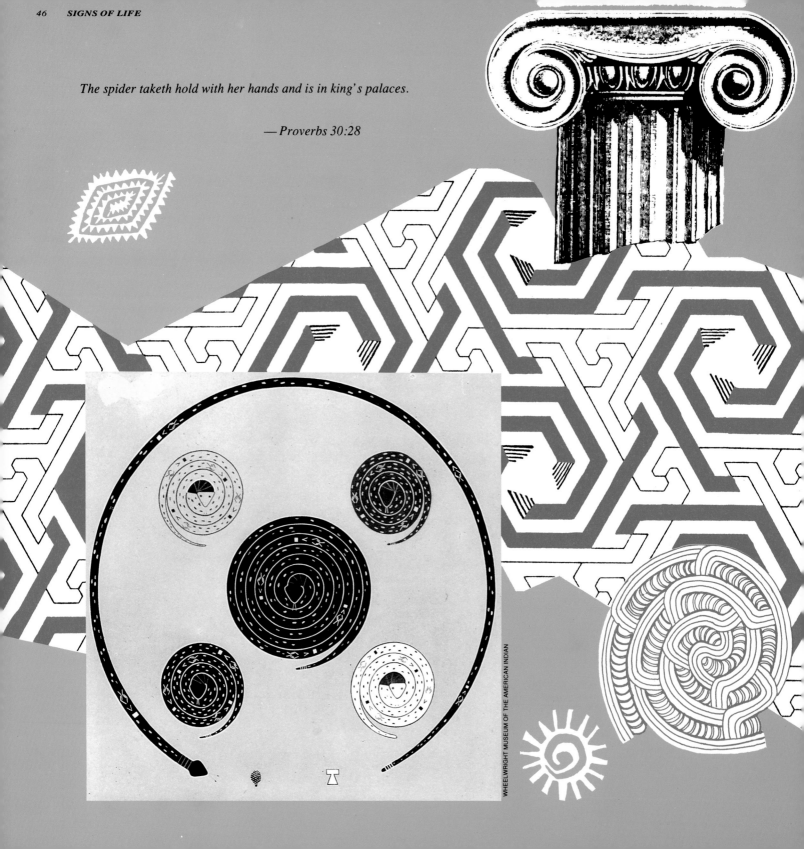

WHEELWRIGHT MUSEUM OF THE AMERICAN INDIAN

THE SPIRAL

Growth and Change

THE SPIRAL SYMBOLIZES THE PROCESS of growth and evolution. It is a process of coming to the same point again and again, but at a different level, so that everything is seen in a new light. The result is a new perspective on issues, people, and places.

Those involved in the spiral process have a strong need for variety, novelty, and change. They dread routine and they are capable of doing multiple tasks well. Creative and ingenious, they are adept at initiating and following up on projects, although they may have some difficulty completing them. The challenge of this process is to grow and develop at different levels of awareness. During times of change, creativity is required to handle life's situations and challenges with integrity.

Flexibility is the major requirement for relating to people who are deep in the spiral process. It is important that others be open to new options not previously considered. The paramount task is to support change rather than to hinder it. People in this process will feel loved and trusted when others share their excitement about the variety of options they are considering. They flourish when their capacity to do varied tasks well is acknowledged.

If allowed to go to an extreme, however, this process can lead to dilettantism, to the superficial exploration of many things at once. It may also be interpreted by others as a pattern of creating chaos to experience momentary excitement and to escape boredom.

46 **a–*Center background*:** Arabic dodecagon pattern; **b and e–*Upper left and Lower center*:** Ancient clay stamps, Mexico; **c–*Upper right*:** Ionic cornice; **d–*Lower left photo*:** Navajo sand painting; **f–*Lower right*:** Carved spiral pattern, New Zealand. **47** **a–*Upper left*:** Blue lotus detail, tomb wall painting, Egypt, eighteenth dynasty; **b and c–*Lower right*:** Arm bands, New Guinea and Solomon Islands.

HAINUWELE MYTH

Ancient myth from the Indonesian island of West Ceram

. . . it is told that the maiden Hainuwele was killed by the people on the ninth night of the Maro festival whilst standing at the central point of the spiral dance, distributing gifts to the people. One of the virgin goddesses of the island, Satene, decided to punish the people for their evil deed.

So she built on one of the dance grounds a great gate, consisting of a ninefold spiral like the one formed by the men in the dance; and she stood on a great log inside this gate, holding in her two hands the two arms of Hainuwele. Then, summoning the people, she said to them, "Because you have killed, I refuse to live here any more: today I shall leave. And so now you must all try to come to me through this gate. Those who succeed will remain people, but for those who fail something else will happen." They tried to come through the spiral gate, but not all succeeded, and everyone who failed was turned into either an animal or a spirit.

Fig. 2.

The life-renewing potential of the spiral appears in the spinning and weaving stories from all cultures. Some examples are the fairy tale, *Rumpelstiltskin*; Native American tales of Spider Woman; stories of Anansi, Spider Man, the trickster figure from Africa; and the European myths involving Arachne.

In Greek mythology, Arachne, the most skillful weaver of Lydia, challenged Athena to a weaving contest. Athena wove into her web the stories of those who had aroused the anger of the gods, while Arachne chose stories of the gods' errors. Enraged at the excellence of Arachne's work, Athena tore Arachne's web to tatters. Arachne hung herself in grief and was transformed by Athena into a spider.

Like the spider, which demonstrates consistent resourcefulness in creating its web, we have in our own natures the relentless power of the creative spirit. The myth of Arachne reminds us of the deep grief felt when creative endeavors are not honored and respected by ourselves and by others. The spiral in art and the spiral metaphor used in mythological spinning and weaving stories are both symbols for the same universal process of growth. They each announce the desire for diverse expressions of creativity.

It is a natural function for human beings to grow, change, and evolve. The ancient myth, *Hainuwele*, at the beginning of this section,

48 **a–*Center*:** Mola design, Cuna Indians, Panama; **b–*Middle right*:** Japanese family crest design symbolizing lightning; **c–*Lower right*:** Drawing of elliptical volute. **49 a–*Upper left*:** Ancient polished pottery bowl, Sikyatki, Arizona; **b–*Lower right*:** Man's silver earring, Sunda Islands.

illustrates that any process of change is an opportunity to approach a familiar situation differently from the way it has been approached in the past, and to rectify what was done before. The modern-day story of change, *Discovering a Hole in the Universe*, beginning on Page 52, points out that as people grow they impact each other in subtle and pervasive ways. In these stories, both Satene and Marge are initiators who highlight the importance of not taking people or life itself for granted as we make changes.

PERSONAL TEST INTERPRETATION

Are you strongly affected by the stories of Arachne and Rumpelstiltskin? Do you remember other tales of spinning or weaving which hold meaning for you? Your answers to these questions will help you to undertand the influence of the process of growth and change in your life now.

Where and when do you notice the sprial shape in your life — everywhere and every day, seldom, or never? Does it carry excitement for you or does it leave you feeling indifferent?

The position you chose for the spiral when you took the **Preferential Shapes Test** *signifies the level of importance change holds for you. If the*

spiral is in Position 1, it shows that the process of growth is the one you believe to be the most important for you at this time. You want to develop flexibility, to handle situations differently from the way you have in the past, and to implement tangible changes in your life. The spiral in Position 2 denotes that it is easy for you to handle change, whether you know this or not. Your actions let others see that your strengths are flexibility and the ability to do many things at once. In Position 3, the spiral symbolizes that you are profoundly engaged in the process of change. It is essential to honor the changes occurring within your nature. Change and variety are necessary in your life. When you are able to trust this process, great energy will be released into all areas of your life. Locating the spiral in Position 4 lets you know that you were challenged in the past to make significant changes in your life. Meeting those challenges readied you for your current breakthrough work as shown by the shape in Position 3. When the spiral is found in Position 5, it means you are unlikely to show interest in the process of growth and change.

Working with the information you have gathered about your level of preference for the spiral will bring into focus that area of your inner map which depicts growth. You will know better how to respond to the idea and to the reality of change in yourself.

50 **a–*Left border*:** Weaving and pottery design, Maricopa, Arizona; **b–*Lower right*:** Enamelled bronze Celtic scroll pattern, Great Britain.
51 Engraved brass plate, Iran, tenth–eleventh centuries.

Simple Truths/Lynne Whiteley Novy

DISCOVERING A HOLE IN THE UNIVERSE

A NEIGHBOR'S message on our answering machine informed me that Marge had died. In her sleep. She was 86.

My first reaction was rather dismissive: "Well, she had a long life, and it was time," I told myself. It wasn't until I passed the news to my husband that a whole mixed bag of feelings began to surface.

"Oh, no!" was Fred's response. "Things won't be the same. I'll miss her."

I felt a colossal stab of guilt. I wasn't so sure I'd miss the nosy old lady across the street who loved gossip and watched us like a hawk.

Fred said he'd miss the early morning ritual of moving her newspaper from lawn to doorstep. He'd miss the evening ritual of waving as he passed her kitchen window on the way home.

He recalled admiring her dual purpose band saw, which she used to split frozen filet mignon into manageable portions to fit her dwindling appetite and to cut metal tubes for her distinctive windchime creations.

He wondered how it would be to raise our flag without Marge raising hers in response, as was their arrangement because he was usually more sure of what day it was than she.

No more sprinklers to fix. No more taking the baby-blue "mint condition" Thunderbird out on the freeway for exercise. No more first-hand tales of early Petaluma.

I felt terrible. Bad that I wasn't as caring as Fred. Sad that I was supposed to feel differently than I did. Mad that there was no way to avoid sorting out the truth of my relationship, or lack of it, with Marge.

Fred went off to telephone a neighbor for details. I tuned the TV to Jeopardy! and competed for answers to easier questions while pounding veal into see-through scallopini.

After dinner, as I pulled the livingroom shade, I realized that I had never lowered or raised it in the four years we'd lived in the house without thinking of Marge. Without concern about closing her out or wondering about letting her in.

Shortly after we moved in, Marge invited us to her pre-dinner cocktail hour: one Bombay gin martini straight up with a Spanish olive. From her kitchen counter, the view took us straight through our own picture window across the way. Fred

called it her command post: there were enough windows in that kitchen to keep tabs on everyone in the neighborhood.

When she visited me for tea, she told me her life story, "except for the really sexy part," which she wanted to save so she'd have something new to tell. It wasn't long before I realized that our "conversations" were one-sided.

She chattered — about sex, death, other people, her short marriage, loneliness — and I listened. If I tried to talk, she would point out that she didn't have her hearing aid. When I finally understood that she needed more from me than I could willingly give, I pulled away.

Although I still waved as I passed her window, or stopped for quick hellos, all major communication happened through Fred. He can chat and then easily say goodby in ways that I cannot.

Birthday cards, garden tomatoes, fresh baked cookies — all crossed the road via the Fred express. I wondered how she felt, until Fred reported a message clearly intended for me: "Marge says she understands that Gemini people are fickle."

Remembering that, I decided we'd had a relationship much to complex to sort out, finished closing the shades, and went to bed.

A few days later, I waved automatically as I drove past the command post. Without warning, I burst into tears. I stopped the car, overwhelmed with the loss.

No return wave. No smiling face at the window. No raised martini glass. No Marge.

A hole in the universe.

I knew more what Fred missed: a part of our lives gone, some kind of security whisked away, homebase changed forever.

But I also felt something deeper: a part of me had gone with her, a part of her remained behind. Beneath our differences lay the inseparable connectedness of us all.

As I got out of the car, I heard the clear tones of the windchime Marge had made for us with her band saw.

—© 1991 Lynne Whiteley Novy

"To dream the impossible dream"
— Song from *Man of La Mancha*

SUSAN MIDDLETON, CALIFORNIA ACADEMY OF SCIENCES

THE TRIANGLE

Goals, Dreams, Visions

THE TRIANGLE IS ASSOCIATED with pyramids, arrowheads, and sacred mountains. It carries the theme of self-discovery and revelation. This shape stands for goals, visions, and dreams.

People experiencing the triangular process are intensely focused on identifying and pursuing a goal; attaining it is extremely important to them. They have the innate gift of vision and their greatest need is to follow their dreams. Their worst fear is that there will be no dreams to pursue. They will persevere despite substantial obstacles and delays for as long as their goals have meaning for them. They need, however, to avoid becoming so absorbed in their plans for the future that they accomplish nothing in the present. That is a pitfall of the triangular process if it is taken to excess.

People in this process will feel loved and accepted when others share and value the visions they hold. Relationships will benefit when family and friends express respect and tangible support for the visions and goals this person pursues.

The triangle is the universal shape associated with the attainment of desired goals, and with the ability to envision new possibilities. Because many people have either achieved or abandoned their earlier goals by mid-life, the envisioning process revealed by the triangle may become a predominant requirement for them as they are faced with the need to *re-dream* and *re-vision* the purpose of their lives. Success in revisioning can lead to a burst of energy for these new pursuits.

54 **a–*Lower left*:** Geometric pattern symbolizing fish, Brazil; **b–*Background*:** Amish quilt pattern *Roman Stripes*; **c–*Left*:** Paddle from Neu-Mecklenburg with pattern symbolizing spiral opercula of snails, triangular wings of frigate bird; **d–*Center photo*:** Polychrome jar, Acoma Pueblo.
55 **a–*Upper left*:** Triangular design, prehistoric pueblo; **b–*Lower right*:** Pottery vase, Naqada, Egypt, mid-fourth century, B.C.

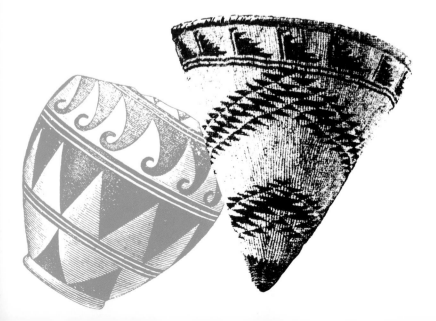

NANSHE

Ancient Babylonian myth

Nanshe, "Interpreter of Dreams", is the Babylonian title of the
Goddess who gave her priests the ability to interpret and prophesy
from other men's dreams. To acquire this ability, priests underwent
an initiation ceremony of descent into her "pit," a symbolic death
and resurrection, like that of the Old Testament Joseph who inter-
preted Pharaoh's dreams. Nanshe was also a Goddess of water and
fertility, her symbol a vessel of water with a fish in it, signifying the
gravid womb.

Many myths from different cultures describe the process of questing for the purpose of attaining a goal, manifesting a new dream, or finding a lost treasure. Most familiar to Westerners are the Arthurian legends, particularly the quest for the Holy Grail. The biblical story of Christ's journey into the wilderness for forty days and forty nights reveals the process of re-visioning, as does the Native American initiation tradition of Vision Quests. All cultures carry stories of sacred mountains, from Parnassus, the ancient mount of the Muse, to Japan's Mount Fuji, considered by the Japanese people to be the point of contact between heaven and the underworld. Climbing a mountain, spending solitary time in a desert, and going into the heart of a forest are frequent mythic themes that describe the processes of searching, seeking, and questing.

Visions, dreams, and goals are basic expressions of human nature. Respect for the process of dreaming, of envisioning creative possibilities, is found worldwide. The Delphic oracles in Greece were revered for their gifts of prophecy and vision. In the ancient Babylonian myth, *Nanshe*, on the previous page, the goddess Nanshe initiates the priests into the gift of vision. The modern-day story, *Dancing on Cosmic Jell-o*, which ends this section, describes the courage needed when going after a goal and the satisfaction that is experienced when it is fulfilled. Both stories demonstrate that dreams and goals are essential in order to manifest creative results.

56 **a–*Lower left***: Etruscan vase; **b–*Lower center***: Maidu twined basket, rim pattern symbolizing mountains, body pattern symbolizing flying geese; **c–*Upper right***: Portion of God figure, sand painting, Navajo, Arizona/New Mexico; **d–*Upper center***: Cloth.
 57 **a–*Lower left***: See *c, previous page;* **b–*Upper right***: Brahmanic Trimurti symbol.

PERSONAL TEST INTERPRETATION

Do you have favorite stories about going on a quest and following a vision? These myths tell of the requirements and rewards of this process, and show that goals are possible to attain. Your interest in such tales, or lack of it, will highlight your relationship to the triangle process.

Are you aware of triangular shapes in your environment? What is your emotional response to them — pleasure, indifference, irritation? What dreams and visions have you followed in the past? What goals have you attained? What dreams from the past have you never attained? Answers to all of the above questions will fill in more detail regarding the value which the triangular process now holds for you.

In the **Preferential Shapes Test**, *your degree of attention to current goals and dreams is measured by the position you chose for the triangle. If the triangle is in Position 1 the process of envisioning seems most significant for you now. You desire to manifest certain goals and dreams within reachable time-frames. The triangle in Position 2 indicates that you carry the gift of vision naturally, though you may be unaware of that. Your behavior indicates to others that you are a visionary, that you can create goals and attain them. In Position 3, the triangle means that the process of envisioning is central to your current development. It is essen-*

58 Wooden mask, Urua, Congo. **59 a–***Lower left***:** Torn paper; **b–***Middle upper right***:** Pottery bowl, Egypt, mid-fourth millenium, B.C.; **c–***Upper right***:** Thunderbird and lightning motifs, Woodlands Indians, The Great Lakes, nineteenth century.

tial for you to honor the goals and dreams that are important to you. When you are completely involved in this process, your efforts will assure that your full powers of inspiration and envisioning are easily accessible to you. Now is the time to actualize your goals and dreams. The triangle in Position 4 shows that your own process of following dreams in the past motivated you to make meaningful changes in your life. Past visions and goals prepared and inspired you to move in the direction of your core work in the present, designated by the shape you have placed in Position 3. When the triangle is found in Position 5, you may be resisting the process of honoring your dreams and establishing goals. The need to manifest your goals or to envision new possibilities is not a desired process for you now.

Interpreting your preference for the triangle will clarify your current position in relation to the gift of vision you carry. The value that you give to dreams and visions will become evident and you will understand your response to the process of setting and achieving goals.

Simple Truths/_Lynne Whiteley Novy_

DANCING ON
COSMIC JELL-O

AN OLD friend called from the East Coast yesterday to tell me times are hard.

"I can't get anywhere," Ken said. "I think they made up that phrase 'dime a dozen' just to describe writers in New York."

Then he told me he had a story stuck in his computer that was a spellcheck away from being finished.

"I can't get myself to do it," he said. "They're only paying $80."

Of course, you and I know what to tell him. We'd say: "Are you nuts? Just finish it, send it in, and use the 80 bucks to pay the phone bill."

But the truth is, Ken knows that, too. How come we don't act on what we know when life gets difficult?

Maybe it has something to do with that expression we all know: "When the going gets tough, the tough get going." I don't like it. I think most of us are already too tough.

No. I prefer my cosmic Jell-O approach. It's a way of working in tune with the universe rather than forcing something out of it at gunpoint. It requires a shift of perspective.

I imagine consciousness as an infinite sea of Jell-O. We've all got a spot on it, and when we move in tune with our own particular rhythm right where we are, our wave reverberates through the whole cosmos. What comes back around to us, from an unexpected direction, is what we need. It may not be what we thought we wanted.

There's a trick to cosmic Jell-O dancing: You step with positive intent and wide-eyed expectancy. You glide, opening to all possibilities. You whirl without hanging onto how it's going to turn out. (For a more sophisticated version, check out Carl Jung on synchronicity, Lao Tsu on the Tao, or even Catherine Ponder on prosperity.)

I first experienced it as a kid in 1955 when Jell-O was a major food group.

At 13 I set out one Saturday to get a job. My mother thought this an overly optimistic enterprise in our little Idaho mining town where times weren't just tough, they were desperate. But I interviewed every shopkeeper on Main Street and beyond.

They all said no.

I remember standing at the end of the street as dusk descended, reassessing what was impor-

— *The Process of Goals, Dreams, Visions*

tant in life. Proving my mother wrong clearly outweighed money, as did doing anything that might make me popular by the time I got to high school.

Decision made, I went back to The House of Flowers and told Mrs. Griffith that hers was the best business in town and that I would be working for her after school and on Saturdays. For free.

She protested. I admired her corsage technique. (She used glitter-edged net puffs amongst the roses and carnations. Any high school girl with a shoulder to pin it on wore Mrs. Griffith's creations on dance dates.)

She hesitated. I assured her my future depended on glitter. (Somehow corsage proximity would transform me into A Popular Girl.)

She agreed. After a few weeks of free sweeping and dusting, I was on the payroll and up to my elbows in glitter.

But I was never Homecoming Queen.

What I got instead was an unshakeable confidence that I could make something happen in the world just by being me. By dancing right where I was.

Unfortunately, this is not something once learned, never forgotten. Over the years, I've left a lot of skid marks on the Jell-O.

Fear breeds amnesia, and when I get scared, I come to a dead stop. And sink.

The way out, I've discovered, is to tell the truth about my predicament, unhook my objecting mind, and give my whole heart to what's in front of me to do.

Once when I did this, I took a terrible temporary job that would scarcely pay the rent. The job never got any better, but I did meet my future husband.

Which leads back to Ken.

What if he were to run the spellcheck, hop a train and personally deliver his story. Maybe this isn't about 80 bucks. Maybe it's about a train ride into town.

— © 1991 Lynne Whiteley Novy

60, 61 Clay stamp designs, Mexico.

The square is not a subconscious form. It is the creation of intuitive reason.

It is the face of the new art.

The square is a living, royal infant.

It is the first step of pure creation in art. Before it, there were naive deformities and copies of nature.

Our world of art has become new, non-objective, pure . . .

— Kasimir Malevich

WERNER FORMAN ARCHIVE

THE SQUARE
Stability

THE SQUARE SYMBOLIZES STABILITY, solidity, and security. The act of drawing a square mirrors perfectly the process of constructing a foundation. Harriet Beecher Stowe validates the positive aspects of the square process when she says, "To be really great in little things, to be truly noble and heroic in the insipid details of everyday life, is a virtue so rare as to be worthy of canonization."

Those attracted to the square are ready to build, to implement a plan, and to manifest ideas. These people have a strong need for consistency, accountability, and completion. Their fear is that nothing will be accomplished and that their efforts will be only a waste of time and energy. They want results. They value integrity and authenticity, as well as responsibility and accountability. Congruity is especially important to them.

62 **a–*Upper left and center*:** Classic Navajo blanket pattern, New Mexico/Arizona, nineteenth century; **b–*Lower left*:** Sundi woven mat design, Congo; **c–*Upper right*:** Ornamental pendant, Tekke–Turkmenian; **d–*Lower right photo*:** Figure from ninth century bowl found in burial mound, western Norway, Celtic in style, probably made in Ireland. **63 a–*Upper left*:** Celtic knot design; **b–*Lower right*:** Elephant, embroidered cloth wall hanging, Kutch, Gujarat, India; **c–*Right border*:** Torn paper.

GU
Ancient myth from Africa
In Fon mythology, Gu is the heavenly blacksmith. On the second day
of creation Mawu-Lisa, the creator god, sent Gu to make the earth
habitable for mankind, and "this work he has never relinquished."
Alternatively, Gu is conceived of as a magical weapon given by Mawu
to Lisa, when she told him to go to the earth and clear the forests, and
show human beings the use of metal so that they might fashion tools.

Actions speak louder than words in dealing with people who prefer the square. Aligning actions *with* words will help establish an atmosphere of cooperation and trust. The problem with the square process, effective as it is for getting things done, is that those who become too deeply immersed in it may become controlling, impatient, and suspicious of others. Those close to people in this process can offer support by being honest, direct, clear, consistent, responsible, and dependable. The most effective way to support these people is to say what you mean and do what you say. When others interact with them in this way, the tendency to move into the shadow area of this process may be avoided.

In many cultures, it is held that the four points of the square symbolize the foundations of life itself. Examples of foundation metaphors found

64 a–Lower left: Zulu carved wooden figure, Republic of South Africa; **b–Upper center**: Perspective drawing, Netherlands, sixteenth century. **65 a–Lower center**: West–Gothic buckle, Figoret–Guzarques, Herault, France; **b–Lower right**: Birchbark basket, Alaska.

in myths include the four seasons, the four elements, the four directions, the four Gospels, the four noble truths of Buddhism, and the Four Corners area for Native Americans in the Southwest. In Jungian psychology it is held that when people dream about anything in a series of four, something is being secured and solidified within their nature. Shamanic traditions believe that when an animal appears four times during a meditative journey, it means that the animal is the person's power animal or helping ally.

Wherever the square appears in art, and whenever examples of foundation metaphors are expressed in myths, the process of stability is being reinforced. The desire for security and congruity indicates that the person is experiencing the square process.

In the ancient myth from Africa near the beginning of this section, the blacksmith Gu demonstrates the process of making things more stable when he helps human beings fashion tools so that they can become more productive. The modern-day myth, *Catching Woodies in Real Life*, at the end of this section, shows that most acts of creativity generate stability and security. This story reveals that things cannot be made secure without the essential ingredients of integrity and authenticity. When solid foundations exist, creativity, responsibility, and authenticity are usually present.

PERSONAL TEST INTERPRETATION

In your life, waking or dreaming, are you aware of metaphors relating to the number four or occurring in a series of four? Are there life situations or stories where your own authenticity seems necessary? Are you conscious of what level of security and stability you offer to others? How responsible and dependable are you on your own and with others?

Do you notice square shapes around you — seldom or often? Do you search for them or avoid looking at them? What feelings come up when you are aware of squares and squareness? Time spent in thinking about and answering the above questions will prove valuable in describing your relationship to the process of stability at this time.

Your present location with the process of stability and responsibility is shown in the **Preferential Shapes Test** *by where you have placed the square. If it is in Position 1, stability and authenticity have your attention and are sources of inspiration to you. You value the alignment of words and actions. The square in Position 2 indicates that your inherent strengths are responsibility, authenticity, and the ability to be fully committed when you give your word. You may not be aware of this ability. Your actions tell others that you are reliable and you are known and valued for your integrity. In Position 3, the square means that the*

66 a–*Upper left*: Woven Chilkat style ceremonial shirt with otter fur, symbolizing Brown Bear, his wife and cub, Tlingit, Yukutat, Alaska;
b–*Background*: Rice paper. **67** Colored-silk embroidered king–at–arms frock from the reign of Philip II, Madrid.

process of stability is occurring at the core of your nature. It is vitally important for you to stabilize and implement your creative endeavors. You need things to be tangible and productive. Expressing your authenticity is essential for you at this time. When you participate in this process with all your attention, untapped creativity and well-being will become available to you. The square in Position 4 announces that past issues of responsibility and accountability led you to make substantial changes in your life. Past situations requiring consistency and stability prepared and motivated you to move in the direction of your present core work as shown by the shape in Position 3. When the square is in Position 5, you may be denying the process of stability and responsibility. The need to be consistent and congruent is not a primary focus for you, nor are you interested in exploring it now.

The importance of stability and responsibility will become more clear to you as a result of exploring the meaning of your preference for the square.

Simple Truths/*Lynne Whiteley Novy*

CATCHING WOODIES
IN REAL LIFE

MAYBE if I'd known about catching woodies when I was a kid I'd have gotten off to a better start with poetry. Maybe with life too.

As it was, I grew up thinking that English poetry, like life, was at best confusing. More often it seemed beyond comprehension.

Poetry had to be just so. And, I imagined, so did I. As poets work and rework words, I shaped and reshaped myself.

Sonnets got 14 lines and no more. (Hips got 36 inches max.) Odes were lyrical and emotional. (Hair turned under at the temple and flipped at the shoulder.) Meter matched rhyme. (Plaids never mixed with polka dots.)

Although I struggled relentlessly with it, I never got my physical package to conform to such lofty standards. If I hadn't been too fat to be a cheerleader, perhaps poetry wouldn't have been such a big deal. But it was. My reputation hung on a 4.0 grade average.

As an English whiz kid I had an image to protect. To whom, then, could I disclose that Grecian urns (much less odes to them) made no sense to me? If Keats eluded me, what was left?

So I faked it.

I pretended to be intimate with iambic pentameter. I composed papers about Shelley and Wordsworth, while wondering what skylarks and trailing clouds of glory had to do with getting a date for the prom. I ripped the tell-tale black and yellow covers off Cliffs Notes and rewrote analyses of *Hamlet* and *Macbeth*.

All the while, with held breath, I waited to be found out.

My breath still catches when I hear that hallowed name: Shakespeare.

Not until years later, when I ran into a little book called *Woody and Me* by Mary Neville, did I begin to breathe freely again where poetry was concerned. Here's one of her poems:
In our town there's a street
Called Pleasant Street
We don't live on it.
At breakfast, if Woody and me
Are arguing,
Mother says,
"Well —
They wouldn't let us
Live on Pleasant Street."

— *The Process of Stability*

Poetry with no rules. No nightingales or darling buds of May. Just plain and honest, probably like the author herself. I could connect because I knew they sure wouldn't let me live on Pleasant Street either. And I was no longer invested in pretending that I could.

But it was Jacqueline Jackson who coined the term "catching woodies" after she read *Woodie and Me* and realized that her family had been collecting similar poetic bits for years. In her book, *Turn Not Pale, Beloved Snail*, Jackson tells kids who want to learn to write: "You're catching a poem rather than sitting down and composing it."

Such freedom. Both for poetry and for life.

Woodies show up whole, as moments that contain their own meaning and rhythm, like this by Jackson's 8-year-old Megan:
Do you know
What love is
To me?
It's when I'm
Swimming in cold water
And suddenly hit
A warm spot.

Woodies aren't out to impress anyone. No plans to be beautiful or perfect or stylized. No faking it.

Here's another by Demi Jackson at 13:
Today in gym
I couldn't play because
Of my sprained foot
And so I picked dandelions
And stuck them in the fence to spell "hi"
But the wind kept blowing them out.
Finally I got them to stay
And limped to the outfield
To see how it looked
To the other kids
And it said "ih."

To me, a woody is a slice of life caught like a fly ball in the outfield. It's ordinary and it's honest.

It's a simple truth.

Faking it, about poetry or anything else, is painful. It's always based on a fear of not being good enough, and we all do it to some degree, one way or the other. Truth telling is the route to self acceptance—and easy breathing.

This column is about catching woodies. Not woody poems, but woody stories. It's about uncovering the Simple Truths locked in the everyday happenings of life. In the process, perhaps it can help to unravel some of our confusion about relationships, family, purposes in life, creativity, love, death, birth, marriage, work — all our deepest concerns.

—©1991 Lynne Whiteley Novy

68 a–*Lower left*: American Indian finger-woven sash design, Great Lakes, eighteenth–nineteenth centuries; **b–*Upper right*:** Created texture; **c–*Background*:** Rice paper, Japan.
69 a–*Center*: Created texture; **b–*Background*:** Rice paper, Japan.

AMOTKEN
Creation myth from the Selish, one of the oldest North American Indian peoples

Amotken made five young women out of five hairs taken from his head. When he asked them what they wanted to be, he received five different replies. The first wanted to become the mother of wickedness; the second the mother of goodness; the third, mother earth; the fourth, the mother of fire; and the fifth, the mother of water. Amotken fulfilled their wishes and said that at first wicked men shall be in the majority, but later on the good will rule over the world.

THE METROPOLITAN MUSEUM OF ART

PART III

PERSONAL INTEGRATION
AND PROFESSIONAL APPLICATIONS

Transforming Energy

*T*he tendencies represented by the shapes are present in all of us all of the time; but certain of those tendencies will predominate at any given time. The **Preferential Shapes Test** provides an overview of your current relationship to the five shapes and shows where the next shifts may occur. This information can be useful in a variety of ways.

Have your **Preferential Shapes Test** in front of you for reference as you read this section.

PERSONAL INTEGRATION

By applying the insights gleaned from interpreting your results from the **Preferential Shapes Test**, you can begin to see how the shapes in the Positions 1 through 5 relate to one another. For instance, tension always exists between the tendencies symbolized in Positions 1 and 5. This tension is sometimes experienced as a conflict. One example is if you have the spiral in Position 1 and the square in Position 5, you may consciously yearn for change (the spiral), but the part of you that is attached to stability and security (the square) may feel unwilling or unable to change.

70 a–*Lower left*: Carved wooden statue, Dogon, Mali; **b–*Center*:** Embroidered folk design, India.
71 a–*Upper left*: Ancient Pueblo pottery design; **b–*Right border*:** Torn paper.

Another instance of this tension is if you have the circle in Position 1 and the cross in Position 5. These preferences may indicate a conscious desire for independence (the circle) that conflicts at a deep level with the desire for relationship (the cross). A third illustration is if you chose the triangle for Position 1 and the spiral for Position 5. Your long term goals (the triangle) are strongly felt, but it may be difficult to follow any systematic method (the spiral) for achieving them.

The first and last positions define an internal struggle. Resolving the struggle means finding a middle ground. Look to Position 3, which often contains the key to personal integration and increased well-being.

In the words of the 12th century Persian poet Rumi:

> "Out beyond ideas of wrongdoing and rightdoing,
> there is a field. I'll meet you there."

Whichever shape you have placed in Position 3 is that "field," the place of integration where you can synthesize your experience.

The shape in Position 5 stands for tendencies you wish to avoid and represents your current idea of wrongdoing. *The shape in Position 1 symbolizes the tendencies that appeal to you at this time and that is your current idea of* rightdoing. *Position 3 represents the field where these opposing forces can be released. It is the place of integration, a place where you can transcend your conflicts by accessing your own infinite sources of creativity and healing.*

Consider, for example, that you have a square in Position 1, a spiral in Position 5, and a circle in Position 3. Your desire for stability (the square) is in conflict with your unacknowledged need for change (the spiral), and the key to resolution is in supporting your current primary need for independence (the circle).

"Something sacred, that's it," Picasso once said. "We ought to be able to say that word, or something like it, but people would take it the wrong way, and give it a meaning it hasn't got. We ought to be able to say that such and such a painting is as it is, with its capacity for power, because it is 'touched by God.' But people would put a wrong interpretation on it. And yet it's the nearest we can get to the truth."

72 a–*Left border*: Torn paper. **b–*Lower left*:**
Bronze baptismal font, Menardt Church, Hungary,
fourteenth century; **c–*Upper right*:** Bead work
design, plant motif, American Indian, eighteenth–
nineteenth centuries.
73 a–*Upper right*: Danish gilt silver brooch
found in sixth century Anglo–Saxon grave;
b–*Right border*: Torn paper.

Nature creates all beings without erring: this is its straightness.

It is calm and still: this is its foursquareness.

It tolerates all creatures equally: this is its greatness.

—*I Ching*, Hexagram #2

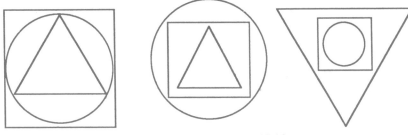

DRAWING MANDALAS

One simple and powerful technique for becoming aware of and empowered by the processes working within you, which you have discovered by interpreting your results from the **Preferential Shapes Test***, is to draw or paint an ongoing series of mandalas.*

Mandalas are geometric combinations that create a unified whole. Mandala is Sanskrit for that of essence (manda — essence; la — of).

Using the symbols that occupy your Positions 1, 3, and 5, experiment with different combinations of these three shapes. The illustrations on these pages show possible mandala forms combining the circle, square, and triangle. You might use any media to do this — collage, pen and ink, torn paper, simple pencil doodling, or even visualization.

As Jung pointed out, symbols are linked with the deep structures of the human psyche. Integrating symbols externally sets up an inner experience that contributes to personal harmony and balance. That is why the mandala exercise, drawn with your primary symbols from Positions 1, 3, and 5, begins to create a symbolic structure that will support personal transformation of energy.

Daily practice is vital to transformation. This means taking some deliberate action each day to access and support the process symbolized in Position 3. Drawing mandalas is one procedure you can take. Other possibilities include writing in a journal, playing music, and practicing some form of meditation.

The symbol of heaven is the circle, and that of earth is the square.
Thus squareness is a primary quality of the earth. On the other hand,
movement in a straight line, as well as magnitude, is a primary
quality of the creative.

—*I Ching*, Hexagram #2

PROFESSIONAL APPLICATIONS

The personal benefits of working with the **Preferential Shapes Test** can also be extended professionally to others. The test can be used to identify current tendencies, conflicts, and resources as a first step in assisting others with their personal growth and integration.

COUNSELING INDIVIDUALS:

The shape in Position 3 gives counselors, consultants, managers, and therapists a clue to where the most important work may presently lie. For example, a person who puts the **circle** in Position 3 is undergoing a critical process of individuation and needs the counselor's full and conscious support for this work. Someone with the **cross** in the middle position needs understanding while dealing with issues regarding relationship, balance, and intimacy. One who has placed the **square** in Position 3 is signaling readiness to begin addressing issues of accountability, of making actions align with words. Individuals who have chosen the **triangle** for Position 3 need to receive assurance for establishing new goals, in envisioning new possibilities, and in making plans for the future. The

76, 77 *Background:* Design from a book cover, Yi, Korea, fifteenth century.

spiral in Position 3 symbolizes the need for variety and change. A person with the **spiral** in this position can be supported to do many tasks at the same time and should be encouraged to implement desired changes. The clues revealed by the shape in Position 3 can help to direct the counseling process to areas where it will be most productive.

For Indians, images are a means of celebrating mystery and not a manner of explaining it.

—Jamake Highwater

COUNSELING COUPLES:

In addition to its applications in individual counseling, the **Preferential Shapes Test** can also pinpoint problem areas with couples. Just as an individual experiences internal conflict between the processes symbolized by the shapes placed in Positions 1 and 5, there will be external tension between two people who have different shapes in their most preferred position, Position 1. The test can be used not only to show areas of conflict, but also to identify the resources each person can use to actualize resolution of the conflict. A frequent source of discord for couples is based on the tension between the process represented by the cross (relationship) and the process represented by the circle (wholeness). People who choose the cross for Position 1 and who need to feel *connection*,

may often ask their partners, "What time will you be home tonight?" The partner with the circle in Position 1, who needs the feeling of *spaciousness*, often will reply, just as typically, "I can't say."

Tension is usually the result of such an exchange between partners. When this tension can be understood in terms of current life processes rather than fixed personality traits, couples will be better able to curb the tendency to judge and blame each other. Time and space need to be negotiated with compassion and understanding of oneself and of the other person. If the person who prefers the cross is assured of having quality time with the partner, it is easier for that person to respect the partner's need for space, symbolized by the circle.

The following example further illustrates how to compare the choices of two people who have selected different shapes for each position. The differing shapes and positions indicate possible areas of opposition, challenge, inspiration, and enrichment for this couple.

Preferential Shapes Test Results

Person A: 1. ◯ 2. ◎ 3. ▢ 4. ✚ 5. △

Person B: 1. ✚ 2. △ 3. ◎ 4. ▢ 5. ◯

Position 1: The process represented by the shape placed here is the one the person feels sure is the most valuable. Person A (the circle) desires the experience of independence and self-reliance and wants space and time alone. Person B (the cross) desires the experience of connectedness and relationship and wants to share quality time with loved ones.

Position 2: The process carried by the shape placed in this position is an inherent strength in the person at this time. Person A (the spiral) brings the intrinsic strengths of flexibility, and ease in handling change to the relationship, while Person B's natural strength is the capacity to envision, dream, and attain desired goals (the triangle).

Position 3: Shown here is the core work that must be attended to in order to follow the process operating most deeply within each person's nature. Person A (the square) needs to explore deeply the process of becoming stable, consistent, and authentic. In contrast, Person B (the spiral) must become involved in the need for variety and be willing to make the necessary changes that stimulate growth.

Position 4: Here is shown the challenge of the past that motivated and prepared the person to attend to the current core work symbolized by the shape in Position 3. Person A's past work on relationships (the cross) served as the impulse to become more responsible and authentic in the present, the square in Position 3. Person B's past work with stability and consistency (the square) motivated the present deep work to change and grow in the present, the spiral in Position 3.

78 a–*Center background:* (dark band) Pattern from carved wooden sculpture, Congo–Kinshasa; **b–***Lower left to upper right:* (light band) Bushongo embroidered cloth pattern, Congo–Kinshasa. **79** a–*Lower right:* Reliquary Hermes of St. Ladislaus, silver gilt ornamented with chain mail, Hungary, fifteenth century; **b–***Lower right background:* Carved pattern from wooden keg, Congo.

Position 5: Whichever process is represented here, the person now considers it unimportant or boring. Both persons may deny or resist the process related to the shape they have placed in this position. Person A (the triangle) does not want to envision the future and is uninterested in setting and attaining goals. Person B (the circle) has little or no desire to explore the theme of independence and self-reliance.

Couples sharing identical shapes in identical positions often experience compatibility, ease, or boredom in the relationship. Because both are experiencing similar processes, they will feel either supported and understood by each other or in need of more stimulation to circumvent boredom.

> *Eskimo art reflects the absence of the notion of creation. There is no real equivalent of our words "create" or "make". The closest term means "to work on"; it is a restrained kind of activity, like the aim of the Eskimo carver of ivory to release the characteristic form of the piece in hand.*
>
> — Arthur Cotterell

BUSINESS, FAMILY AND GROUP APPLICATIONS:

Business, family, and other group endeavors are exciting areas for application of the **Preferential Shapes Test** information. The aim is to develop support in two areas: for a person's individual growth and for how that person can best contribute to the goals of the group.

The symbol in Position 3 on each person's test is the critical one to be developed and supported. People with the **circle** in this position will perform well doing independent work. People who choose the **square** for Position 3 will make excellent administrators, keeping track of details and following through. Those who have the **triangle** in this position are natural planners and brainstormers who will feel frustrated if assigned a job that leaves no space for creative thinking. The people who choose the equidistant **cross** for Position 3 are ready to exercise their skills in dealing with other people. Those who select the **spiral** for the middle position are versatile workers who can do many tasks well and will require the stimulation of constant new challenges.

In every case, the test results can help managers and career counselors appropriately match a person with a job in a way that will promote individual career growth as well as overall productivity. An excellent resource for additional psychological and business applications of all the shapes, except the cross, are found in Susan Delligner's comprehensive book, *Psycho-Geometrics: How to Use Geometric Psychology to Influence People.* She demonstrates how to use shapes as a way of understanding different behaviors and for increasing human effectiveness.

Non-business groups, such as families, service organizations, and groups working together for a one-time special project will find the foregoing information pertinent and useful. Additionally, a chart can be made and displayed showing each group member's **Preferential Shapes Test** results. Simply draw a vertical column for each person and put the person's name at the top. List that person's preferential choices in five

80 a–*Left*: Large coiled grain storage basket, Apache, Arizona, nineteenth century; **b–*Lower center*:** Modern American pottery vase with traditional motifs; **c–*Upper right*:** Olympic symbol. **81 a–*Middle left*:** Male and female symbols; **b–*Lower right*:** Imbricated baskets, Lillooet, British Columbia and Washington.

boxes in the column, one below the other. Do the same for each person. Everyone's choice for each position will be lined up horizontally for easy visual reference. It is helpful to look at everyone's choices for one particular position, considering the possibilities and needs. By noting the shapes in both Positions 1 and 5, conflicts may be predicted and circumvented before they begin. All the shapes in Positions 1 and 5 can remind everyone of the processes and attributes considered *most* and *least* interesting and admirable; tolerance can be encouraged and developed. Natural abilities, shown by the shapes in Position 2, can direct the right person to the right task. The core work in which each person is most deeply involved, as shown in the third position, can be easily supported and honored.

The **Preferential Shapes Test** has special value when the backgrounds of the people who have taken the test differ, as they often do in today's increasingly global community. Because it is cross-cultural and based on universal symbols, the test can cut through misunderstandings caused by cultural differences and illuminate the essence of what is happening. The test information can be useful in guiding personal and professional choices, in resolving a variety of conflicts, and for supporting natural talents.

When the process in Position 3 is strongly supported, individuals experience more fully who they are and become more effective and productive; infinite amounts of innovation and renewal become available.

The symbol in Position 3 represents the place where architects recognize, as form builders, what Mimi Lobell has written: "Architecture

82 *a–Left and right*: Ornamental tile, rooster design, Paekche, Korea, seventh century; **b–***Upper center*: Clay stamp, Mexico City; **c–***Lower right*: Cloth.
83 *Lower right*: Basque cross.

is the art form that engages society in its entirety and marshals the most extravagant resources to build a mediator between the self and the cosmos." We become architects and mediators of our own lives and environment by attending to the process that is revealed to us in Position 3.

As we and others respond to and nourish the process in the third position, it becomes the source that furthers natural growth and change. This is the place where our own inner guidance appears. It allows a clearer vision to be achieved and leads to a reconnection with the inherent kindness at the center of us all. The result of our work will be a shift, a transformation, and a renewed sense of self which Antonio Machado so eloquently describes.

Last night, as I was sleeping,
I dreamt — marvelous error! —
that I had a beehive
here inside my heart.
And the golden bees
were making white combs
and sweet honey
from my old failures.

PART 1V

THE MAKING OF THIS BOOK

*"In the creation of all art, many helpers come
forward to support the vision." — Anonymous*

THERE WERE TWO INVALUABLE
resources that I used for obtaining this cross-cultural information. The first is *The Human
Relations Area File (HRAF) 1949-1990,* an index
of material available in oral as well as in written
form, listed by subject and country. The second is
*The Motif-Index of Folk Literature, A Classifica-
tion of Narrative Elements in Folk Tales, Ballads,
Myths, Fables, Mediaeval Romances, Exempla,
Fabliaux, Jest-Books & Local Legends,* a six-volume work containing comprehensive listings
of themes, subjects, images, and symbols found in
many societies throughout the world. For these
and other necessary resources, I am indebted to
the influence and work of Alan Dundes, anthro-pologist and professor of folklore at U.C. Berke-ley.

I am deeply grateful to science writer M.H.
Wayne for her ability to simplify and translate the
majority of this cross-cultural exploration. Terry
Ryan and Thom Elkjer made the material more
consolidated and accessible by their excellent
editorial feedback. It was Terry who also came up
with the wonderful title for this book.

The following resources confirmed for me
the perennial human themes represented in these
five basic shapes: *Larousse's Mythology; The
Dictionary of World Mythology; The Dictionary
of Mythology, Folklore, and Legend,* and the
works of C.G. Jung, Joseph Campbell, Robert
Bly, Jamake Highwater, and Barbara Walker.

I was motivated to design the **Preferential
Shapes Test** by the information contained in
ancient myths as well as by contemporary re-search on the same subject. The early collected
works of Andrew Lang, a twelve-volume set of
fairy tales collected by country and known as *The
Rainbow Book* or *Fairy Book Collection* is a
major resource for me. For current information, I
turned to the work of psychiatrist Allan Chinen,
*In the Ever After: Fairy Tales and the Second
Half of Life*; and Roger Lipsey's excellent classic,
*An Art of Our Own: The Spiritual in Twentieth
Century Art.*

I am grateful for the comprehensive feed-back provided for me by over two hundred of my
graduate students at the California Institute of
Integral Studies, J.F.K. Universtity, and at the
Institute of Transpersonal Psychology. Their
enthusiasm for this material gave me the courage
to take it into other workshops across the country.
I also included this material as an article in my
teaching module, *Cross-Cultural Values and
Transpersonal Experience*, for the External
Degree Program at the Institute of Transpersonal
Psychology. I was supported in this developmen-

tal process by graduate student Cynthia Mc Reynolds, who contributed a high quality of editorial assistance.

Paul Hinckley, environmental designer, and Carolyn Conger, therapist and teacher, inspired author Michael Crichton to invite me to present this material as a keynote address at the 1987 International Aspen Design Conference in Colorado. For this wonderful opportunity to share my work, I am deeply grateful. As a result, representatives from Hallmark Cards asked me to give a similar presentation on the universal shapes at Hallmark's Creative Leadership Conference and Seminars. To Jon Henderson, Debra Ketchum, and others at Hallmark, I am grateful for the chance to offer the shapes information as a part of their programs. These two conferences involved fifteen hundred people from the field of creative arts who further substantiated and validated these ideas.

I have been deeply influenced by the architectural writings of Christopher Alexander, R.B. Fuller, Richard Neutra, and Mimi Lobell. Their work reinforced and encouraged me to continue with this study when I began to wonder why I was doing all of this. The efforts of environmental designer Paul Hinckley to extend the shapes into his own work and to pass the material on to others brought forth new connections and applications that I had not previously considered.

Educational pioneers Hugh and Nancee Redmond gave my ideas generous support at their Transformational Arts Institute in Redlands, California. The following are examples of other innovative programs that amplify the importance of creative work: Natalie Roger's Expressive Arts Therapy Program in Santa Rosa, California; the Mask-Making Workshops led by Nancee Redmond and those given by Suki Munsell in Mill Valley, California; the curriculum design of the Creative Arts Program founded by Jill Mellick at The Institute of Transpersonal Psychology in Menlo Park, California. These endeavors and others like them signal to me the timeliness and relevance of this work.

Other professional colleagues and friends saw how this material could be further used. I have been inspired as they extended the range of this concept into their own areas of expertise. Frances Vaughan, psychotherapist and author of *The Inward Arc: Healing and Wholeness in Psychotherapy and Spirituality*, urged me to put the material into book form and was willing to take these findings into some of her workshops. The value of her feedback and consistent support as a friend and colleague has been inestimable. Jeanne Achterberg's impeccable research and practical applications continue to be stimulating whenever I speak with her or re-read her book, *Imagery and Healing: Shamanism and Modern Medicine*. I am especially grateful to Holotropic Breath-Work founders, Christina and Stan Grof

for the many opportunities they have provided for me to present my work over the years.

Lynne Whitely Novy's talent as a writer and insight as a psychotherapist inspired me to juxtapose modern and ancient myths to show how the processes represented by the shapes are pervasive through time. Her good humor, evident in her newspaper column, *Simple Truths*, allows readers to recognize and to be open to mythic themes in everyday life. I am grateful to her for her friendship and for her permission to include five of her columns in this book.

I was delighted to discover Susan Dellinger's work in 1989. Her book, *Psycho-Geometrics: How to Use Geometric Psychology to Influence People,* addresses all of the shapes except the cross. Although her approach and methodology are very different from mine, some of the meanings attributed to the behaviors of her geometric shapes are similar. Her work provides a guideline for understanding and influencing the behavior of people in order to enhance effectiveness and productivity on the job and at home.

Mimi Lobell's innovative concept of shapes that she calls "Spatial Archetypes" inspired me. She describes how shapes in architecture can be used for maintaining the integrity of our own nature and of natural environments. The work of Susan Dellinger and of Mimi Lobell are fine resources for further exploration and for a deeper understanding of the material in this book. ·

In expanding my work on symbols, it was important to me to see how the five universal shapes have been used throughout the centuries and in cultures world wide. I began to collect selections which address these ideas from literature, poetry, art, and music. My vision of this book was that it would include ancient and modern myths and examples of the shapes from all the races and from all the continents. Over the previous decade I have collected cross-cultural images from books, magazines, and from other media. I would like to thank Loralee Denny for her assistance with this collection.

I am grateful to the C.G. Jung Institute of San Francisco for the use of their multi-cultural visual archives known as *ARAS, The Archive for Research in Archetypal Symbolism*. This collection contains over thirteen thousand photographic images from all over the world and from all periods of human history.

I had worked previously with designer and illustrator Peggy Mackenzie on my book, *The Tarot Handbook*. I realized that if anyone could capture the complexity of what I wanted to achieve visually with *Signs of Life*, it would be Peggy. She is an exceptionally talented and creative woman who has been able to use diverse images as a way of providing a cross-cultural and expanded experience of the meaning of the text. The book is designed to provide both a left-brain and a right-brain experience. I wanted the content

of the book to exemplify the relentless power of the creative spirit consistently present in universal themes and symbols. Peggy's exquisite design captures human nature's desire for creative expression and beauty. She has achieved the vision I had in mind; I am deeply touched with her work.

To the mother and two-daughter team of Arcus Publishing Company, Betty Gordon, Anne Mackenzie, and Peggy Mackenzie, I extend honor and respect for their commitment to creativity, beauty, and excellence. I am thankful to this family of women and to their staff, especially to Judith Stephenson for her editorial help.

The production of this book would not have taken place without the vision, the skills, and the time extended by the people involved with it. All of the pre-publication work for this book was done by women who love to do their work in ways that heal, nurture, and support others. This reinforces my belief in the power of collective work and shared vision.

To my own staff, which includes my sister, I extend unlimited gratitude for the quality of support they extend to me. These women embrace a sense of fun and demonstrate concentrated productivity and professionalism. I deeply appreciate Twainhart Hill for her innate creativity, organizational skills, and attention to detail in gathering permissions needed for the materials used here. Her healing presence was essential in pulling together all parts of this book. Carolyn Cappai maintained daily office activities and communication with good humor and consistent flexibility when the full force of creative fervor and production hit its peak. Jane McKean was readily available at the computer when I needed her for elaborate entries and concentrated work sessions. Her expertise and many skills gave me confidence that we would ultimately succeed in the face of any challenge presented.

My sister, Joanne Arrien, continues to support my endeavors by fulfilling orders for my tapes, books, and articles. Her own artistic abilities and capacity to create beauty is a constant reminder to me to do the very best I can in all that I do.

To the many named and unnamed helpers, I give unlimited thanks for their generosity of spirit and support in manifesting the creative vision of this book.

Angeles Arrien
Sausalito, California
April, 1992

PART V

NOTES

The titles of the books and articles noted by author and date of publication are listed in full in the bibliography. Those extracts where permissions have been given are gratefully acknowledged.

P. 10 AMONG THE LANGUAGE . . . : Highwater, 13.

P. 15 ARCHITECTURE IS THE WILL . . . : van de Rohe, 74.

P. 16 WHILE I STOOD THERE . . . : Neihart, 43.

P. 17 WHO CAN AFFORD TO . . . : Ferrucci, 13.

P. 17 ACCORDING TO CARL JUNG . . . : Jung, *Symbols of Transformation.*

P. 17 . . . IT IS THE ARTIST . . . : Campbell, *Inner Reaches of Outer Space.*

P. 18 I DON'T THINK THAT . . . : Lipsey, 355.

P. 19 THE SOUL NEVER THINKS . . . : Aristotle, 663.

P. 19 IN A VERY BRIEF SPAN . . . : Harris/Moran, 30.

P. 19 IN HUMAN AFFAIRS . . . : Wilhelm/Baynes, 91.

P. 21 I AM A HISTORY . . . : Paz, 149.

P. 22 I WILL SPEAK TO YOU . . . : Paz, 67.

P. 30 CIRCLES . . . : Neihart, 194, 195.

P. 32 KUNAPIPI . . . : Cotterell, 278

P. 36-7 FEELING GOOD ABOUT GRANDMA . . . : Novy.

P. 38 MAN, ALONE IN HIS MANLINESS . . . : Grigg, 37.

P. 40 MASEWI . . . : Cotterell, 218.

P. 40 IN *TIMAEUS* . . . : Plato, 18.

P. 44-5 A LITTLE BIRDIE TOLD ME . . . : Novy.

P. 46 THE SPIDER TAKETH . . . : Prov. 30:28.

P. 48 HAINUWELE . . . : Schnapper, 22.

P. 49 TALES OF SPIDER WOMAN . . . : Allen.

P. 49 STORIES OF ANANSI . . . : Mbiti.

P. 49 IN GREEK MYTHOLOGY, ARACHNE . . . : *New Larousse Encyclopedia of Mythology*

P. 52-3 DISCOVERING A HOLE IN THE UNIVERSE . . . : Novy.

P. 54 TO DREAM THE IMPOSSIBLE DREAM . . . : Darion.

P. 56 NANSHE . . . : Walker, 718.

P. 60-1 DANCING ON COSMIC JELLO . . . : Novy.

P. 62 THE SQUARE IS NOT A SUBCONSCIOUS FORM . . . : Karshan, 118.

P. 63 TO BE REALLY GREAT . . . : Warner and Beilenson, 23.

P. 64 GU . . . : Cotterell, 241.

P. 68-9 CATCHING WOODIES IN REAL LIFE . . . : Novy.

P. 70 AMOTKEN . . . : Cotterell, 202.

P. 72 OUT BEYOND IDEAS OF WRONGDOING . . . : Rumi, 8. *Open Secret.*

P. 73 SOMETHING SACRED, THAT'S IT . . . : Lispsey, 19.

P. 74 NATURE CREATES ALL BEINGS . . . : Wilhelm/Baynes, 14.

P. 76 THE SYMBOL OF HEAVEN . . . : Wilhelm/Baynes, 13.

P. 77 FOR INDIANS, IMAGES ARE A MEANS . . . : Highwater, 65.

P. 80 ESKIMO ART REFLECTS . . . : Cotterell, 227.

P. 82-3 ARCHITECTURE IS THE ART FORM . . . : Lobell, 72.

P. 83 LAST NIGHT, AS I WAS SLEEPING . . . : Machado, 43.

BIBLIOGRAPHY

ARAS. The Archive for Research in Archetypal Symbolism. C. G. Jung Institute of San Francisco.

Achterberg, Jeanne. *Imagery and Healing: Shamanism and Modern Medicine.* Boston: New Science Library, 1985.

Alexander, Christopher. *A Pattern Language*: New York: Oxford University Press, 1977.

Allen, Paula Gunn. *The Sacred Hoop: Recovering the Feminine in American Indian Traditions.* Boston: Beacon Press, 1986.

Anderson, William. *Green Man: The Archetype of Our Oneness with the Earth.* San Francisco: Harper/Collins, 1990.

Aold, Rhoda L. *Molas.* New York: Van Nostrand Reinhold Co., 1980.

Apostolos-Cappadonna, Diane, ed. *Art, Creativity, and the Sacred: An Anthology in Religion and Art.* New York: Crossroad Publishers, 1984.

Arguelles, Jose. *The Mandala.* Boston: Shambhala Press, 1985.

Aristotle. *Works of Aristotle.*Vol 1. Chicago: Encyclopedia Britannica, Inc., 1952.

Arrien, Angeles. "Cross-Cultural Spiritual Perspectives." Teaching Module, Institute of Transpersonal Psychology, External Degree Program, Menlo Park, Calif., 1985.

————. "Cross-Cultural Values and Transpersonal Experience." Teaching Module, Institute of Transpersonal Psychology, External Degree Program, Menlo Park, Calif., 1987.

————. *The Tarot Handbook: Practical Applications of Ancient Visual Symbols.* Sonoma, Calif.: Arcus Publishing Company, 1987.

Ashton, Dore, ed. *Twentieth-Century Artists on Art.* New York: Pantheon, 1986.

Barr, Alfred H., Jr. *Picasso: Fifty Years of His Art.* New York: Museum of Modern Art, 1946.

Bayley, Harold. *The Lost Language of Symbolism*, Vols. 1 and 2. New York: Carol Publishing Group, 1989.

Beck, Peggy V. and Walters, Anna L. *The Sacred: Ways of Knowledge, Sources of Life.* 2nd ed. Tsaile (Navajo Nation), Ariz.: Navajo Community College Press, 1988.

Bernbaum, Edwin. *Sacred Mountains of the World.* San Francisco: Sierra Club Books, 1990.

Bible. King James Version. New York: The World Publishing Company.

Billard, Jules B. *The World of the American Indian.* Washington D.C.: National Geographic Society, 1974.

Bowlt, John E. *Russian Art of the Avant-Garde: Theory and Criticism 1902-1934.* New York: Thames and Hudson, 1976.

Burland, Cottie. *North American Mythology.* New York: The Hamlyn Publishing Group, 1970.

Campbell, J. *Inner Reaches of Outer Space: Metaphor as Myth and as Religion.* Toronto: Alfred Vander Marck Editions, St. James Press, Ltd., 1986.

————. *The Hero with a Thousand Faces.* 2nd ed. Bollingen Series 17 Princeton, N. J. : Princeton University Press, 1968.

Charbonneau-Lassay, Louis. "The Ouroboros." *Parabola*, XV, No. 1, Spring 1990, 53-54.

Chesi, Gert. *The Last Africans.* Austria: Perlinger-Verlag, 1978.

Chekov, Michael. *To the Actor on the Technique of Acting.* New York: Harper & Row, 1953.

Chinen, Alan. *In the Ever After: Fairy Tales and the Second Half of Life.* Wilmete, Ill.: Chiron Publications, 1989.

Coe, Ralph T. Sacred Circles: Two Thousand Years of American Indian Art. Exhibition, Nelson Gallery of Art, Atkins Museum of Fine Arts, Kansas City, Missouri, 1977.

Cootner, Cathryn M. *Anatolian Kilims.* The Fine Arts Museums of San Francisco, London: Hali Publications, 1990.

Cornell, Judith. *Drawing the Light from Within.* New York: Prentice Hall Press, 1990.

Cotterell, Arthur. *A Dictionary of World Mythology.* Oxford: Oxford University Press, 1986.

Cousineau, Phil, ed. *The Hero's Journey: Joseph Campbell on His Life and Work.* San Francisco: Harper & Row, 1990.

Darion, Joe, lyricist. *The Man of La Mancha.* "To Dream The Impossible Dream." Song. 1965.

Davis, Courtney. *The Celtic Art Source Book.* London: Blandford Press, 1988.

Daumal, René. *Mount Analogue.* Boston: Shambhala Press, 1986.

Dellinger, Susan. *Psycho Geometrics: How to Use Geometric Psychology to Influence People.* Englewood Cliffs, N.J.: Prentice-Hall, Inc., 1989.

Dundes, Alan. *Every Man His Way: Readings in Cultural Anthropology.* Englewood Cliffs, N.J.: Prentice-Hall, Inc., 1986.

Eliade, Mircea. *Symbolism, the Sacred and the Arts*, edited by Diane Apostolos-Cappadona. New York: Crossroad Publishing, 1988.

————. *The Quest: History and Meaning in Religion*. Chicago: University of Chicago Press, 1969.

Eliot, Alexander. *The Universal Myths: Heroes, Gods, Tricksters, and Others*. New York: New American Library, 1976.

Ferrucci, Piero. *Inevitable Grace*. Los Angeles: Jeremy Tarcher, 1990.

Fisher, Angela. *Africa Adorned*. New York: Harry N. Abrams, Inc., 1984.

Fuller, R. B. *Synergetics 2*. New York: MacMillan, 1979.

————. *Critical Path*. New York: St. Martin's Press, 1981.

Gimbutas, Marija. *The Goddesses and Gods of Old Europe: Myths and Cult Images*. London: Thames and Hudson Ltd., 1982.

Goldwater, Robert. *Symbolism*. New York: Harper & Row, 1979.

Grigg, Ray. *Tao of Relationships*. Atlanta: Humanics, Ltd., 1988.

Hague, Michael. *Mother Goose*. New York: Henry Holt & Co., 1984.

Harman, Willis and Rheingold, Howard. *Higher Creativity: Liberating the Unconscious for Breakthrough Insights*. Los Angeles: An Institute of Noetic Sciences Book, Jeremy Tarcher, Inc., 1984.

Harris, Philip R. and Moran, Robert T. *Managing Cultural Differences*. Houston: Gulf Publishing Co., 1978.

Helfmann, Elizabeth S. *Signs and Symbols Around the World*. New York: Lathrop, Lee & Shepard Publ. Co., 1967.

Highwater, Jamake. *The Primal Mind: Vision and Reality in Indian America*. New York: A Meridian Book, New American Library, 1982.

Human Relations Area File. Country Survey Series. Survey of World Cultures. HRAF Files, Inc. New Haven, Conn.: New Hraf Press/Yale University Press, 1949-1990.

Jung, C. G. *Man and His Symbols*. Garden City, N.J.: Doubleday, 1964.

————. *Symbols of Transformation*, Vol. 5 *of the Collected Works of C. G. Jung*. Trans. by R. F. C. Hull. Princeton, N.J.: Princeton University Press, 1956.

Karshan, Donald. *Malevich, The Graphic Work: 1913-1930, Print Catalog Raisonne*. Jerusalem: The Israel Museum, 1975.

Lagorio, Valerie and Day, Mildred L., eds. *King Arthur Through the Ages*. Vols. 1 and 2. New York: Gardland Publishing, Inc., 1990.

Lahr, Jane and Tabori, Lena. *Love: A Celebration in Art and Literature*. New York: Stewart, Tabori & Chang, 1982.

Lang, Andrew, ed. *the Fairy Book Collection*, 12 Vols. New York: Dover Publications, 1965-1968.

Lanker, Brian. *I Dream a World: Portraits of Black Women Who Changed America*. New York: Stewart, Tabori & Chang, 1989.

Lawlor, Robert. *Sacred Geometry*. New York: The Crossroad Publishing Company, 1982.

Leach and Fried, eds. *Standard Dictionary of Folklore, Mythology, and Legend*. Ramsey, N.J.: Funk & Wagnall Co., Inc., 1972.

Lehner, Ernst. *Symbols, Signs and Signets*. New York: Dover Publications, Inc., 1950.

Levy, G. R. *Religious Conceptions of the Stone Age and Their Influence upon European Thought*. New York: Harper & Row, 1963.

Lewis, Hunter. *A Question of Values: Six Ways We Make the Personal Choices That Shape Our Lives*. San Francisco: Harper & Row, 1990.

Lipsey, Roger. *An Art of Our Own: The Spiritual in Twentieth Century Art*. Boston: Shambhala Press, 1988.

Lobell, Mimi. "Spatial Archetypes." *Revision: A Journal of Consciousness and Change*, Vol.6, No. 2, Fall 1983, 69-82.

London, Peter. *No More Secondhand Art: Awakening the Artist Within*. Boston: Shambhala Press, 1989.

Machado, Antonio. *Times Alone: Selected Poems of Antonio Machado*. Trans. by Robert Bly. Middletown, Conn.: Wesleyan University Press, 1983.

Marlin, William, ed. *Nature Near: Late Essays of Richard Neutra*. Santa Barbara, Calif.: Capra Press, 1989.

Marshak, A. *The Roots of Civilization: The Cognitive Beginnings of Man's First Art, Symbol and Notation*. New York: McGraw-Hill, 1971.

Mbiti, J. *Concepts of God in Africa*. New York: Praeger, 1970.

Moon, Beverly, ed. *An Encyclopedia of Archetypal Symbolism*. Boston: Shambhala Press, 1991.

Munro, Eleanor. *Originals: American Women Artists*. New York: Simon & Schuster, 1979.

Naples, Veronica. *Corporate Identity Design.* New York: Van Nostrand Reinhold Co., 1988.

Niehardt, John G. *Black Elk Speaks: Being the Life Story of a Holy Man of the Oglala Sioux.* as told through John G. Niehardt (Flaming Rainbow). Lincoln, Neb.: University of Nebraska Press, 1972.

New Larousse Encyclopedia of Mythology. New York: Hamlyn Publishing Group, 1959.

Noguchi, Isamu. *A Sculptor's World.* New York: Harper & Row, 1968.

Novy, Lynne Whiteley. "Simple Truths." Petaluma, Calif.: *Argus-Courier*, 1991.

Ozenfant. *Foundations of Modern Art.* Trans. by John Rodker. New York: Dover Publications, Inc., 1952.

Paz, Octavio. *Configurations.* Trans. by G. Aroul. New York: New Directions Publishing Corporation, 1971.

———. *Eagle or Sun?* Trans. by Eliot Weinberger. New York: New Directions Publishing Corporation, 1976.

Peck, M. Scott. *The Road Less Travelled.* New York: Touchstone Books by Simon & Schuster, 1978.

Plato. *The Dialogues of Plato.* Trans. by Benjamin Jowett. Chicago: Encyclopedia Britannia, Inc., 1952.

Purce, Jill. *The Mystic Spiral: Journey of the Soul.* New York: Avon Books, 1974.

Read, Herbert. *Art and Society.* New York: Schocken Books, 1966.

Richter, Gisela. *A Handbook of Greek Art.* London: Phaidon Press Ltd., 1959.

Robertson, Jack. *Twentieth-Century Artists on Art: An Index to Artists, Writers, Statements, and Interviews.* Boston: G. K. Hall, 1985.

Rogers, Natalie. *Emerging Woman: A Decade of Midlife Transitions.* Santa Rosa, Calif.: Personal Press, 1980

Rumi. *Open Secret.* Trans. by John Moyne and Coleman Barks. Putney, Vt.: Threshold Books, 1984.

———. *Unseen Rain.* Trans. by John Moyne and Coleman Barks. Putney, Vt.: Threshold Books, 1986.

Safford, Carleton L. and Bishop, Robert. *America's Quilts and Coverlets.* New York: Bonanza Books, 1985.

Schiller, Herbert I. *Communication and Cultural Domination.* White Plains, N.Y.: M. E. Sharpe, 1976.

Schnapper, Edith B. *The Inward Odyssey: The Concepts of the Way in the Great Religions of the World,* 2nd ed. London: George Allen & Unwin, 1980.

Severy, Merle, ed. *Greece and Rome: Builders of Our World.* Washington, D.C.: National Geographic Society, 1968.

Sonfist, Alan. *Art in the Land: A Critical Anthology of Environmental Art.* New York: NAL/Dutton, 1983.

Steiner, Rudolf. *Ancient Myths: Their Meaning and Connection with Evolution.* Toronto: Steiner Book Centre, 1971.

Stewart, Hilary. *Looking at Indian Art of the Northwest Coast.* Seattle: University of Washington Press, 1979.

Strong, Donald E., et al. *Great Art and Artists of the World; Origins of Western Art.* New York: Franklin Watts, Inc., 1965.

Stuart, Gene S. *America's Ancient Cities.* Washington, D.C.: Special Publications Division, National Geographic Society, 1988.

Thompson, Stith. *Motif-Index of Folk Literature: A Classification of Narrative Elements in Folk Tales, Ballads, Myths, Fables, Mediaeval Romances, Exempla, Fabliaux, Jest Books and Local Legends,* 6 Vols. Indiana: Indiana University Press, 1955-1958.

van der Rohe, M. Working Theses. *Programs and manifestoes on twentieth-century architecture.* Ulrich Conrads, ed. Cambridge, Mass.: MIT Press, 1970.

Vantuono, William, ed. and trans. *Sir Gawain and The Green Knight.* New York: Gardland Publishing, Inc., 1991.

Vaughan, Frances. *Inward Arc: Healing and Wholeness in Psychotherapy and Spirituality.* Boston: Shambhala Press, 1986.

von Franz, Marie Louise. *On Dreams and Death.* Boston: Shambhala Press, 1987.

———. *Individuation in Fairytales.* New York: Spring Publications, 1977.

Walker, Barbara. *The Woman's Encyclopedia of Myths and Secrets.* San Francisco: Harper/Collins Publishers, 1983.

Warner, Mary Alice and Beilenson, Dayna, eds. *Women of Faith and Spirit: Their Words and Thoughts.* White Plains, N.Y.: Peter Pauper Press, Inc., 1987.

Wilber, Ken. *No Boundary: Eastern and Western Approaches to Personal Growth.* Boulder, Colo.: Shambhala, 1979.

———. *A Sociable God.* New York: McGraw-Hill, 1983.

Wilhelm, Richard and Baynes, Cary F. *I Ching or Book of Changes.* Princeton, N.J.: Bolligen Series XIX, Princeton University Press, 1967.

INDEX

ILLUSTRATION CREDITS

a	b c	d	o	p q	
e	f	r			
g	h i	t	s		
j					
k	m	u v w			
l	n				

Page 4 **Page 5**

Cultural Information: a–Sandpainting design, Navajo, Arizona/New Mexico; **b**–Gear Symbol; **c**–Cross cramponee; **d**–Design from funerary urn, seventh century, Great Britain; **e**–Amulet container, Atjeh, Sumatra; **f**–Clay spindle whorl, pre-Columbian, Mexico; **g**–Design from funerary urn, seventh century, Great Britain; **h**–Octagram, eight-pointed star formed by a continuous line; **i**–First aid symbol, International Air Transport Association; **j**–Celtic interlacing; **k**–Egyptian geometric seal design; **l**–Bronze pendant, Hungary; **m**–Shield with geometric pattern; **n**–Clay stamp, Tlaxcala, Mexico; **o**–Lightning symbol, Japan; **p**–Design called *back and head of python*, Bushongo, Africa; **q**–Bird design, Egypt; **r**–Fish scale pattern, family crest, Japan; **s**–Hand-shaped flat stamp, Mexico; **t**–Pottery design, Pueblo group, Santo Domingo, New Mexico; **u**–Deer, Mimbres pottery bowl, New Mexico/Arizona, ninth–twelfth centuries; **v**–Egyptian geometric seal design; **w**–Anglo-Saxon metalwork.

The following is a list of all books which are sources of the illustrations used in this book. In the individual credit listings which follow, designated by page number in numerical order, the books can be identified by the numbers assigned to them in the list below.

All items from books published by Dover Publications, Inc. are reprinted by permission. Permissions from sources other than Dover are noted in the individual listings.

1–*African Design from Traditional Sources* by Geoffrey Williams. © 1971 Dover Publications, Inc.

2–*American Builder's Companion, The* by Asher Benjamin. © 1969 Dover Publications, Inc.

3–*Amish Quilt Designs* by Doreen Lynn Saunders. © 1990 Dover Publications, Inc.

4–*Ancient Egyptian Designs for Artists and Craftspeople* by Eva Wilson. © 1986 Dover Publications, Inc.

5–*Arabic Geometrical Pattern and Design* by J. Bourgoin. © 1973 Dover Publications, Inc.

6–*Background Patterns, Textures and Tints* by Clarence P. Hornung.© Dover Publications, Inc.

7–*The Book of Kells* ed. by Blanche Cirker. © 1982 Dover Publications, Inc.

8–*Celtic Designs and Motifs* by Courtney Davis.© 1991 Dover Publications, Inc.

9–*Decorative Art of the Southwestern Indians* by Dorothy Smith Sides. 1961 Dover Publications, Inc.

10–*Decorative Arts of Sweden, The* by Iona Plath. © 1966 Iona Plath. Dover Publications, Inc.

11–*Design Motifs of Ancient Mexico* by Jorge Encisco. © 1953 Dover Publications, Inc.

12–*Designs from Pre-Columbian Mexico* by Jorge Encisco. © 1971 Dover Publications, Inc.

13–*Early Medieval Designs from Britain for Artists and Craftspeople* by Eva Wilson. © 1983 Eva Wilson. Dover Publications, Inc.

14–*Folk Designs from India* by Pradumna and Rosalba Tana. © 1987 Pradumna and Rosalba Tana. Dover Publications, Inc.

15–*Handbook of Designs and Devices* by Clarence P. Hornung. © 1959 Clarence P. Hornung. Dover Publications, Inc.

16–*Handbook of Pictorial Symbols* by Rudolf Modley. © 1976 Dover Publications, Inc.

17–*Islamic Designs for Artists and Craftspeople* by Eva Wilson. © 1988 Eva Wilson. Dover Publications, Inc.

18–*Japanese Design Motifs* compiled by The Matsuya Piece-Goods Store. Trans. by Fumie Adachi. © 1972 Dover Publications, Inc.

19–*Mola Designs* by Frederick W. Shaffer. © 1982 Frederick W. Shaffer. Dover Publications, Inc.

20–*North American Indian Designs for Artists and Craftspeople* by Eva Wilson. © 1984 Eva Wilson. Dover Publications, Inc.

21–*Perspective* by Jan Vredeman de Vries. © 1968 Dover Publications, Inc.

22–*Primitive and Folk Jewelry* ed. by Martin Gerlach. © 1971 Dover Publications, Inc.

23–*Primitive Art* by Franz Boas. © 1955 Dover Publications, Inc.

24–*Styles of Ornament, The* by Alexander Speltz. 1959 Dover Publications, Inc.

25–*Symbols, Signs and Signets* by Ernst Lehner. © 1950 Ernst Lehner. Dover Publications, Inc.

26–*Traditional Chinese Designs* ed. by Stanley Appelbaum. © 1987 Dover Publications, Inc.

27–*Traditional Designs from India for Artists and Craftsmen* by Pradumna and Rosalba Tana. © 1981 Pradumna and Rosalba Tana. Dover Publications, Inc.

28–*Traditional Japanese Design Motifs* by Joseph D'Addetta. © 1984 Dover Publications, Inc.

29–*Traditional Korean Designs* by Madeleine Orban-Szontagh. © 1991 Dover Publications, Inc.

30–*Voyages and Travels* by G.H. Von Langsdorff. © 1968 Gregg Press.

Pages 4 and 5 a–Book #9, Plate 48, d; **b**–Book #16, 41, top row; **c**–Book #15, 113, 1014; **d**–Book #13, 87, top right; **e**–Book #22, 172, Plate 86, f; **f**–Book #12, 1, top right; **g**–Book #13, 87, top right; **h**–Book #15, 151, 1355; **i**–Book #16, 57; **j**–Book #8, 35; **k**–Book #4, 91; **l**–Book #22, 22, Plate 11; **m**–Book #15, 197, 1771; **n**–Book #11, 14, 111; **o**–Book #18, 11,3; **p**–Book #23, 113, f; **q**–Book #4, Plate 16; **r**–Book #18, 116, 9; **s**–Book #11, 134, IV; **t**–Book #9, Plate 27, b; **u**–Book #20, 10; **v**–Book #4, Plate 91; **w**–Book #13, 4.

Page 7 Book #30, Reprinted by permission, Gregg Press, Ridgewood, N.J. **Page 8 and 9** Book #27, 97. **Page 10 a**–Book #6; **b**–Book#18, 209; **c**–Photo Mimbres Pottery Bowl (TM 4589 Mimbres) Colorado Springs Fine Arts Center, Taylor Museum Collection. **Page 11 a**–Book #24, Plate 23, 3; **b**–Book #18, 209. **Page 12** Book #24, 442. **Page 13 a**–Book #23, 173; **b**–Book #25, Plate 410. **Page 14 a**–Photo by permission, United Nations, United Nations Photo: 57,107/ARA; **b**–Book #23, 89, a. **Page 15** Book #23, 56,c. **Page 16 a**–Photo, P. Mackenzie; **b**–Book #21, Plate 46. **Page 17** Book #16, 36. **Page 18** Photo, Isamu Noguchi, Courtesy of the Isamu Noguchi Foundation, Inc. **Page 19** Book #25, 97, 524. **Pages 20 and 21** Book #20, Plate 8. **Page 22** P. Mackenzie. **Page 23 a**–Book #11, 14, 111; **b**–P. Makenzie. **Pages 24–29 a**–Book #15, 197, 1771; **b**–Book #12, 1, upper right; **c**–Book #18, 116, 9; **d**–Book #11, 14, 111; **e**–Book #4, 91. **Page 30 a, b**–Book #1, 36,58; **c**–Photo, Neg. #2A 13677–Buffalo Robe (with circular pattern). Courtesy Department of Library Services, American Museum of Natural History. Photo P. Hollembeak; **d**–Book #25, 57. **Page 31 a**–Book #20, 7; **b**–P. Mackenzie. **Page 32 a**–Book #22, 119, Plate 59, 4; **b**–Book #24, 58, Plate 25, 4; **c**–Book #22, Plate 20, 20; **d**–Book #17, 34–35, Plate 15. **Page 33 a**–Book #22, 119, Plate 59, 1; **b**–Book #1, 120. **Page 34 a**–Book #17, Plate 13; **b**–Book #26, 45, lower right; **c**–Book #17, Plate 20. **Page 35 a**–Book #26, 35; **b**–Book #12, 72. **Pages 36 and 37** Book #6. **Page 38 a**–Book #8, 15, b; **b**–from *Life World Library; Australia and New Zealand*. Photograph by David Moore. © 1964 Time–Life Books Inc.; **c**–Book #20, 4; **d**–Book #22, 121, Plate 60, 21. **Page 39 a, b**–Book #23, Fig. 108, a and c; **c**–Book #25, 100,549; **d**–P. Mackenzie. **Page 40 a**–P. Mackenzie; **b**–Book #15, 78, 697. **Page 41 a**–P. Mackenzie; **b**–Book #20, Plate 33. **Page 42 a**–Book #24, 427; **b**–Book #1, 28, top; **c**–Book #22, 78, 13. **Page 43 a**–Book #21, Plate 1; **b**–Book #24, Plate 79, 5; **c**–Book #1, 28, center. **Pages 44 and 45** Book #3, 28. **Page 46 a**–Book #5, 101; **b, e**–Book #11, 14, 2 and 4; **c**–Book #2, 63; **d**–Courtesy Wheelwright Museum of the American Indian, No.P.PfOA#2; **f**–Book #24, 161, Fig. 137. **Page 47 a**–Book#4, 42; **b, c**–Book #22, Plate 82, 30 and 31. **Page 48 a**–Book #19, 40; **b**–Book #18, 11, 3; **c**–Book #2, Plate VIII. **Page 49 a**– Book #9, Plate 8, a; **b**–Book #22, Plate 21, 3. **Page 50 a**–Book #9, Plate 38, g; **b**–Book #8, Plate 12. **Page 51** Book #17, 1. **Pages 52 and 53** Collection P. Mackenzie. **Page 54 a**–Book #23, 89, c; **b**–Book #8, 17; **c**–Book #23, 107, Fig. 102; **d**–Photography by Susan Middleton. California Academy of Sciences. © 1983. **Page 55 a**–Book #23, 121, Fig.118; **b**–Book #4, 11. **Page 56 a**–Book #24, 35, Fig. 26; **b**–Book #24, 19, Fig. 4; **c**–Book #9, Plate 48, b; **d**–P. Mackenzie. **Page 57** Book #25, 98, 531. **Page 58** Book #23, 70, Fig. 64. **Page 59 a**–P. Mackenzie; **b**–Book #4, 11, lower left; **c**–Book #21, Plate 39. **Pages 60 and 61** Book #11, 3, I and II. **Page 62 a**–Book #20, Fig. 28; **b**–Book #1, 6; **c**–Book #22, Plate 72, 14; **d**–Werner Forum Archive, Ltd., London, Universitetets/Bergen Historisk Museum, Norway. **Page 63 a**–Book #8, 32; **b**–Book #14, 12. **Page 64 a**–Book #1, 99, right; **b**–Book #21, Plate 24. **Page 65 a**–Book #24, 103, Plate 51, 15; **b**–Book #23, 56, Fig. 49, d. **Page 66 a**–Book #20, Plate 74; **b**–P. Mackenzie. **Page 67** Book #24, Plate 144, 1. **Page 68 a**–Book #20, 41; **b**–Book #6; **c**–P. Mackenzie. **Page 69 a**–Book #20; **b**–P. Mackenzie. **Page 70 a**–The Metropolitan Museum of Art, Gift of Lester Wunderman, 1977. (1977.394.15); **b**–Book #14, 19. **Page 71 a**–Book #23, 37, Fig. 31; **b**–P. Mackenzie. **Page 72 a**–P. Mackenzie; **b**–Book #24, 297; **c**–Book #24, Plate 45. **Page 73 a**–Book #13, Plate 4; **b**–P. Mackenzie. **Page 74 a**–Book #1, 28; **b**–Book #8, 6; **c**–Book #4, 9; **d**–Book #7, 20, 129V. **Page 75** P. Mackenzie. **Pages 76 and 77** Book #29, 35. **Page 78 a**–Book #1, 39, top and bottom. **Page 79 a**–Book #24, 296, Plate 176, 5; **b**–Book #1, 60. **Page 80 a**–Book #20, Plate 90; **b**–Book #20, Plate 26; **c**–Book #16, 96. **Page 81 a**–Book #16, 103; **b**–Book #23, 299, Plate XV. **Page 82 a**–Book #29, 13; **b**–Book #11, 11, II; **c**–Cloth. **Page 83** Collection Angeles Arrien.

ANGELES ARRIEN is an author, anthropologist, educator, and corporate consultant. Her teachings are based on the universality of values, ethics, and experiences as they relate to myths, symbols, and the arts. Her research and teaching have focused on beliefs shared by humanity and on applying ancient wisdoms in contemporary times. She bridges the disciplines of anthropology, psychology, comparative religion, and philosophy. She honors her Basque heritage by lecturing nationally and internationally in cross-cultural anthropology and transpersonal psychology at colleges, universities, corporate settings, and growth centers. Her work has been featured on radio and television. She is the author of *The Tarot Handbook: Practical Applications of Ancient Visual Symbols*, published by Arcus Publishing Company, 1987. Besides *Signs of Life: The Five Universal Shapes And How To Use Them*, she also has another new book available in 1992 entitled *The Four-Fold Way: the Paths of the Warrior, Teacher, Healer and Visionary*, published by San Francisco Harper/Collins.